GOD'S CHILDREN

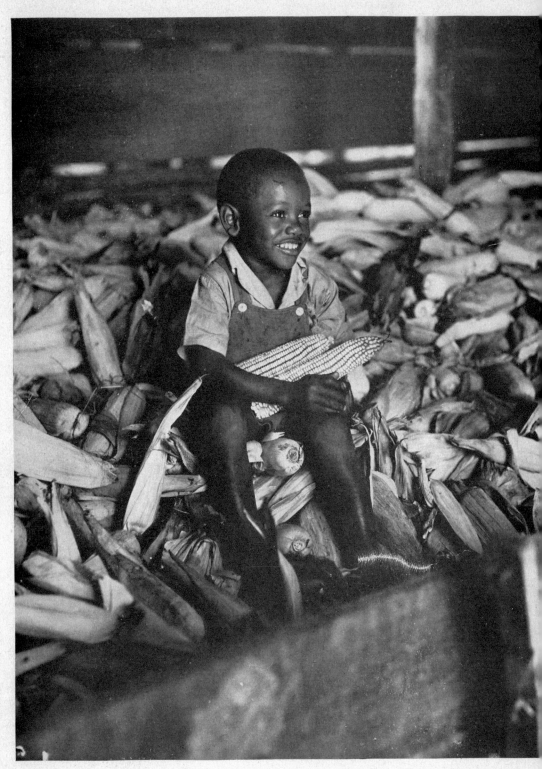

Jack Alston, the son of Hampton's foreman, in the corn crib.

GOD'S CHILDREN

by

Archibald Rutledge

Illustrated with Photographs
by Noble Bretzman

The Bobbs-Merrill Company
Publishers

INDIANAPOLIS NEW YORK

THE CORNWALL PRESS, INC., CORNWALL, N. Y.

To

ELEANOR STEVENSON RUTLEDGE

who ministers to the children of my

Black Henchmen

ACKNOWLEDGMENT

For courteous permission to use some of the material in this book, the author makes grateful acknowledgment to the Editors of The *Saturday Evening Post*.

CONTENTS

GOD'S CHILDREN

36
113.
138

Chapter 1

Black Henchmen

MY FATHER bequeathed to me many friends. Nor could there be a richer heritage than this. Among these were many of the plantation Negroes he had trained in particular skills. Always keen to recognize and to appreciate special aptitudes, he took great pride in his black henchmen, as he called them. They are my best workers today, belonging to a fine old school which took delight in craftsmanship, and knew nothing of mass production. I call these henchmen mine; and I inherited them from my father. They are a part of his fine legacy to me.

While some publicity has been given the American Negro as an artist, and while a very great deal, on the stage, on the screen, and in novels and short stories, has been made of his laziness, his apprehensive superstitions and his general *laissez faire* attitude toward life, no tribute of which I know has ever been paid to him as a loyal and an intelligent worker. And since it is as a worker that I know the Negro best, I should like to give an account of certain of my black henchmen and of the labors they perform. Mention will be made also of what we call special aptitudes. I believe that my story will be heartening to all those who really love the Negro and wish him well. I hope also to reveal other aspects of his character. It appears wise to attempt to do so by recounting certain authentic hap-

penings of plantation life and by telling some true stories of what I have known Negroes to do.

Of course, I live in the wilderness, and on my remote Carolina plantation things are somewhat as they have always been. My Negroes—I call them mine, for they are my people; but more truly, I am theirs—are Nubians; that is, their ancestors were brought from North Africa. Undoubtedly in their veins was some admixture of Egyptian, Moorish and Arab blood. Many of my henchmen are tall, straight and handsome; and their native intelligence is such that I frequently go to them for advice, even on rather intimate personal matters. They know nothing of literature and little of the modern world; but they know, it seems to me, everything about life and about human character. I have long made it a practice never to start any project on the plantation without first consulting some of my henchmen. They can often see farther than I do; and they have the quaint and eerie gift of being able to see around corners.

Recently I decided to put a trunk in the bank of an old abandoned rice field. My place is directly on the river, ten miles above the ocean; and we have fresh tidewater.

This I wanted to control, so that I could dry or flow the field at will. A trunk or floodgate is the only device by which this can be done. In the old days of rice growing in coastal Carolina, there were thousands of trunks made and put into operation; and there were many good trunk-makers, also all among the Negroes. But today old Sambo Green is the only Negro I know who can make one of these wooden floodgates which, by a kind of hydraulic magic, harness the tides; and though we do not often consider this

fact, behind every tide is the incredible might of the ocean.

Sambo Green is old, small, mild-mannered, peering. He is well over seventy, and he walks stoopingly and unsteadily. To me, he perfectly illustrates the fine principle that skill, intelligence and gentleness are often of far more effect than brute strength. I have many Negroes who could tie Sambo up with one hand, but not one of them can make a trunk. Nature endowed him with this certain, if slight, wizardry, and long experience has made him a master in his field.

Set deeply under the banks of old rice fields on my place are similar trunks. Since immediately above some of them grow stately pines and cypresses which cannot be less than a century old, the floodgates beneath them must be much older. Yet with a little work on their doors, these trunks could be made to work today. Therefore the trunk that mild Sambo made for me will be effective a hundred years hence. How few examples of human handicraft, especially those exposed to the elements, last so long!

When the massive lumber was assembled on the bank, near the cut in the dike into which the trunk, when completed, would be lowered, Sambo went to work. Incidentally, he lives four miles from me, but he does not mind walking to and from work. Both on arriving and on departing he can be heard whistling—mildly broadcasting cheerfulness.

Most workmen of today, if they were confronted by the task Sambo faced, would have to be supplied with a multitude of modern gadgets. Sambo had only the elementals: an auger, a saw, a hatchet and an old plane, the box of which he himself had made. Of course his real tools were

his understanding heart, his seeing eye and his sensitive, intelligent hands. He likes to work alone. If I appeared on the scene, he tolerated me very courteously, but I could tell that he knew exactly how to do the thing, whereas I did not. While I questioned him a little, out of curiosity, I refrained from making any suggestions. One must not make suggestions to an artist. Genius is a solitary thing, and knows its way about.

Sambo's task was this: To construct with mathematical precision, out of three-inch planking, a massive box, twenty feet long, four feet wide, and two feet deep, and open at both ends. The mouths, or ends, however, must not be squared. Over the mouth of each is fitted a huge wooden collar, which has outer surfaces so inclined that the bottom extends five inches beyond the top. After a collar is on a trunk, its appearance gives somewhat the impression of a flat-faced cowcatcher on a locomotive.

The doors are so hung on uprights fastened to the trunk that they close on a slope over the mouths. These doors can be raised and lowered at will. When the outer door is up and the lower one is down, the field will be flowed by the flood tide, and will remain flowed; for with the turn of the tide, the inner door will automatically close. When the outside door is down, and the inside door is up, the field will be dried. The doors are held in their desired positions by means of pegs through the uprights.

A trunk can be so operated that water to the fraction of an inch of a certain depth can be put on a field. It was this device, conceived in a day when the growing of rice was an industry of ever-increasing importance, that enabled the South Carolina rice planters to supply the markets of the

world. And the water that they harnessed not only flowed their rice to the proper depth and at strategic times, but was the source of energy that drove their mills for pounding rice. Water power was then the only mechanical power known.

Modest Sambo set to work with his crude tools; he dovetailed and mortised; he rabbeted and drove thole pins; he planed heavy yellow pine until the boards presented gleaming surfaces. I noticed that, every now and then, as the tide ebbed and flowed in the near-by river, he gave it a wary and appraising eye. That, and nothing less, he knew, was the power with which he had to contend. And he realized what it would take in the way of workmanship to control that primeval power. He justly estimated the elemental forces with which he was contending.

Ten days later with the help of twenty Negroes, we got the huge trunk in its place, and then filled in the bank above it. Through it roared the flood tide, and out of it stormed the affluent rupture of ebb, with enough power to run a big mill. But when we dropped either door, instantly and like magic this cosmic force was under control. With no irreverence I may suggest that it was as if gentle little Sambo were saying to the massive might of the Atlantic, "Peace; be still."

Gabriel Myers is one of my oldest friends. I have hunted with him, and he has been my handy man for more than fifty years. When I was a little boy, he was a grown man with a family. He is now, I think, eighty years old, but you would not take him to be more than fifty-five. His hat is so battered that when he wears it he looks unimpressive; but when he takes it off, he is really handsome. While his hair

is graying, his long drooping mustache is black; his features are clear-cut; his eyes are keen; and his swinging step is wary, as befits one who all his life has had to do with the business of outwitting wild game.

When a human being is a Negro, I like to see him black. Being so, contributes to his authenticity. Gabe is very satisfying in this respect. If he were to stand against a burnt pine, you would hardly discern him. Strong, willing, full of fun, capable in many little homely ways, he is possessed of the rare heroism of invincible good nature. I went to see him after his cabin had burned. He had lost everything except one shirt—"and dat was my raggety one," he told me with a smile.

Looking over the total ruin—for even his crops, stacked beside the house, had been consumed—"This is the real depression," I said with massive pessimism.

"Oh, no, I ain't got dat yet," Gabe told me. "You see, I still got hope."

Living several miles from me, he comes to the plantation every day. I always give him work if I have it. If there is nothing doing, Gabe spends the day jovially flirting and gossiping with my cook. She always gives him dinner, and sometimes I think she gives him hers. I usually drive him home.

Handy man that he is, Gabe has made for me innumerable articles out of ash, hickory and oak. He knows woods and how to use them. He makes wooden handles for anything. He builds my fences, He mends my boats. He is forever borrowing my only wagon, to which he attaches his half-wild ox, which always breaks it. But when Gabe brings the wagon back, it is mended. Even at his age, Gabe can

do with cheerfulness and efficiency work that would appall an ordinary man of fifty.

"Gabe," I said not long ago, "I am going to build a house for Sue. I want you to get out the cypress sills for me—four of them, sixteen feet long, and two, twenty feet long. They must be ten inches by ten."

Knowing my man, I could afford to say this lightly. I was as sure of him as I would be uncertain of myself if I were called upon for such a labor. Nor did he need any further specifications. He knew better than I did just where to find suitable black cypress trees.

Within a few minutes Gabe had shouldered an ax and a huge broadax that looked as if it were of Revolutionary vintage—certainly it is a kind of ancestral possession of his —and disappeared into the gloomy cypress swamp to the southward of the house.

Three hours later I visited him at the scene of his labors. He had already thrown down two big cypresses, and one of these he had squared into a sill. In two days he had completed the entire task.

Then, without worrying me with how those giant timbers were to be brought out of that fetid morass, he rode his lunatic ox up to the plantation, equipped it with some kind of weird harness, and by means of an old logging chain he compelled that reluctant and barbarous animal to drag the sills out to the road. Gabe does not hew timbers F. O. B. Swamp, but Delivered.

Gabe has seen a lot of life. He has been married four times. He has twenty-four grandchildren. Before his latest marriage I asked him if he expected to make another matrimonial adventure.

"I might," he admitted, "but I must rest a little first."

It is not only that he can do certain kinds of work remarkably well, but he does it with such a spirit that mine is heartened and sustained. If I live to be eighty, I hope I can take the years as gallantly as Gabe does now.

For many years Alex was the ferryman on the Santee River near me. As a ferryman, he was usually absent from his place of business; and many an hour have I waited for his return to his duties. My inclination to be severe with him was tempered by my remembrance that Alex is and has always been the social lion of the neighborhood. He just has a way with him, and his romantic adventures have long supplied this whole plantation region with gossip. He never distinguished himself as a ferryman; and in his amours I am not really interested. But he does have a gift that I admire. He is a genuine expert in the building of banks.

These banks in question have to do with rice fields, and the earth to be handled is heavy blue mud. Moreover, to handle it, one has to stand in the mud. Alone among the many hundred Negroes of my acquaintance Alex can perform the feat I now describe.

Standing on the quaking morass of a rice field, Alex, with three deft strokes of his spade, cuts loose from its melancholy mooring a block of mud about three times as big as a brick. With matchless co-ordination of muscle and of eye, he heaves the block of mud fifteen or twenty feet to the top of the bank that is being raised.

The mud must not merely be thrown but must be thrown upward, and often Alex cannot see what might be termed his target. But he makes the block fall flat; it falls

exactly in place, close to the one that preceded it. And almost before it has settled securely, here comes another. This heavy mud is laid, from a distance, just as bricks are laid. It is like some magic remote-control building of a wall, with the bricklayer twenty feet away.

Alex can keep this up by the hour, with a tireless rhythm that is profoundly discouraging to all his would-be imitators.

One day I had a visitor watching Alex do his stuff. As he is below medium height, when he was bogged in the mud, he failed to appear to be one capable of heroic feats. I told my friend that Alex could deliver a spadeful of mud into a hat at thirty feet. Scouting the idea, he laid his hat on the bank. Then he called to Alex, telling him that if he would hit the hat, he would give him a dollar. Alex got his money, and I think my friend had to get a new hat.

I might add that Alex is a man of extraordinary courtesy. He is so deferential that he not only always doffs his hat when speaking to a white man but he invariably curtsies. And while I have good reason to suspect that the sight of a neighbor's hog roaming loose is liable to fill him with cupidity, even to the point of action, whenever I have a bank to be built, I send for him.

Anyone who studies the landmarks of the deep coastal South will be amazed at the number and the size of the dikes, still serviceable after two centuries. I never look at one without thinking of the spiritual forebears of Alex. It took men with his peculiar ability to build them, but he is now a kind of solitary craftsman. Yet, as I have intimated, his nature is far from being of a solitary cast.

During the last nine years I have been restoring my

ancient plantation house, and Lewis Colleton is the only man I have ever trusted to do everything with this work. His versatility is amazing. Naturally bright, he has a fair education. Certainly he can work from blueprints. But he was born gifted. Now only thirty-eight, he is, without ever having had any especial training, a master carpenter.

I do not hesitate to put him at the most delicate and exacting cabinetwork. He is an excellent plumber; he can lay concrete; he can hang wallpaper; he is a finished painter; he is something of an expert as a tree surgeon. And for some years he made a living cutting cypress crossties.

The earthquake of 1886, which was especially severe in our neighborhood, shook my old plantation house considerably, breaking off a chimney and cracking one of the foundation walls. It did one other thing which was not discovered until recently: it shook completely out of plumb one of the mighty yellow-pine beams that receive and support the rafters.

This trouble was disclosed when Lewis was putting on a new roof. I was dismayed. I knew of no mechanism that could pull that massive timber back into place. Lewis eyed it appraisingly. "I will fix it," he said.

He bored a hole through the beam, passed a steel rod through, the other end of which he fastened to the corresponding beam on the opposite side of the house. With a hack saw he cut the rod in two. Then he threaded it. Last, he affixed a giant turnbuckle bolt, and slowly drew the beam once more into place. When the sill was in plumb, he spiked it down.

Recently the keystone and the whole top of one of my arched fireplaces collapsed. I think the bricks and mortar

were tired after two hundred and sixteen years. The place looked as if a bomb had been dropped on it.

"Lewis," I said casually as together we surveyed the dusty ruin, "fix that for me."

Personally I was quite helpless. I did not even have any suggestions to make.

The first thing he did was to find somewhere a long flat iron bar. This he bent over some tree roots until he had the precise arch he wanted. Inserting the ends of this into the wall on either side, he built his arch of bricks above it, and I think his job is better than the original.

Naturally, he is in great demand. He is forever fixing everything for everybody. Our Negro church, which long ago would have collapsed but for him, he time and again has repaired. Even the Biological Survey calls on Lewis to mend its boats and to build its wharves. It is not only that he is skillful, and can perform to perfection a great many standard kinds of work. He is highly ingenious, and the more baffling the nature of the task, the more heart-appeal it has for him. In him we find exemplified that fine truth: To an intelligent and daring spirit, the difficult will be done immediately, the impossible, soon.

Once I secured, from an old house that was being torn down, a hundred or more beautiful little glazed tiles that had faced the two sides of the fireplace inside. Then I got a sack of special cement. Then I sent for Lewis, and in a few words explained that I wanted him to set the tiles in my dining-room fireplace. I can still see his eyes brighten as they always do when the task presented is a challenge. I, of course, walked out on him. Before the end of the day he had beautifully finished the job, and had really gone

the second mile, inasmuch as he had added a few artistic touches to the work, embellishments which I had never even conceived.

It is often true that the humblest work well done is a tribute to both skill and character. This fact could hardly be better exemplified than by the case of Steve Boykin. Steve is now seventy-six years old; and while he has lost some of the enthusiasms of his younger years, in one respect he appears to be improving in strength and in skill all the while. He is my plantation woodcutter.

With no other method of heating save by open fires, with a sixteen-room plantation house, and with a vast old kitchen in the yard, with three cavernous fireplaces in it, the importance of firewood can readily be recognized. As I have 3,000 acres from which to draw, there is no dearth of it—rich pine or "lightwood," ash, hickory, white oak, scrub oak and a multitude of other sorts. Steve spends his days cutting wood for me.

Somewhat lame ever since a lumber train ran over the toes of his left foot, he has a characteristic walk, and can be identified by it at a great distance. Nearly every day during the fall and winter good old Steve appears in the backyard, ready for work. As a rule, when I first see him he is sharpening his ax. With him, this partakes of the nature of a religious rite. A good craftsman loves the tools of his trade. Steve hews out of hickory his own ax handles. The blade of his ax he keeps burnished, and the edge keen and bright.

Thirty years ago there was a heavy lumber operation in my woods. All the debris has now disappeared except the solid hearts of the stumps of the huge old yellow pines that were cut. These are almost as hard as metal: and from them

an ordinary woodsman's ax will rebound discouragingly. But Steve confidently, even cheerfully, attacks their massive might. And he is the only man I know who will, by choice, cut dead live oak. This is the hardest native wood of which I have any knowledge.

He always racks up neatly the wood he has cut in the wilds, and in so doing he exercises a commendable secrecy. Steve is a good hider. For he knows that firewood is considered more or less common property, and if he leaves it unconcealed, it will mysteriously vanish. When we prepare to haul in the wood he has cut, he has to go along with us to show us where he has secreted it.

To me Steve is personally fascinating, for he is not only a fine faithful worker, but he remembers and loves the Old Days, and is full of stories of plantation life as he knew it sixty and more years ago. Nor does he hesitate to tell a story against himself. For example, he told me that as a young man he had been haled into the local magistrate's court on the charge of being the father of the child of an unmarried girl. Steve really was innocent (that time), but he said that in the courtroom, while the case was just about to take a favorable turn for him, the baby, possibly with a little urging from the mother, climbed down off her knee and toddled over to him, babbling "Da da."

Steve said the baby appealed to him so much that he pleaded guilty. He raised the child, who, as William Boykin, is another one of my henchmen, his especial aptitude being his amazing skill as a fisherman.

Sometimes if I look at a person's face, I can be provoked at him, but rarely if I look at his hands. They have an eloquence of their own, often pathetically appealing. On one

occasion I was about to reprimand old Steve, my woodcutter, when I happened to look at his hands. Black and gnarled they are. They tell life's story. They remind me how many cords of wood he has cut for me; how many oars he has shaped for my boats; how many handles for hatchets and axes; how many yokes for oxen; perhaps how little I have done for them for all they have done for me. Hands break me down. However beautiful or noble they may be, faces are rarely as poignantly expressive as hands.

My henchmen might be called specialists. When we think of a specialist we conceive of a man who has spent many a laborious year in college and in training. These men I have described have enough native genius to make up for their lack of formal training, and they seem to me akin to the ancient craftsmen of the past—men who did perfect work because they loved it. Any race that can produce such workmen is a race that merits our respect and instinctively has our admiration.

These are among my father's humble friends and mine. Their only pride seems to be in work well done. They were trained in an atmosphere of affection and understanding, of good will, of a recognition and acceptance of the possibilities and the impossibilities in human nature. The mildest of employers, my father somehow put upon them an indelible stamp; it is nothing less than the sign and symbol of every good workman who has discovered the salutary delight of accomplishment. Nor would I know where else to find in America in these days a better group of devoted craftsmen than I have in my black henchmen.

Chapter 2

Plantation Lights and Shadows

I REALIZE that in these glimpses of plantation life, a natural nostalgia may make it appear that in an earlier day all was idyllic. But in no land, at no time has life been anything but an unpredictable series of happenings, some good, some bad. All of us have luck, but much of it is bad. Yet I am not sure but life is enlivened by its uncertainty, as it is made dearer by its insecurity and its brevity. As the long look of the setting sun lights up the fading landscape (especially an autumnal one) with more tenderness than the morning's, mysterious glamours from the haunted west having in them spiritual radiances, full of the implications of immortality—so when we remember the past, turning our eyes backward, we are likely to see, as Henry Timrod so beautifully says:

> A shadowy land where joy and sorrow kiss,
> Each unto each corrective and relief,
> Where dim delights are brightened into bliss
> And nothing wholly perishes but grief.
>
> Ah, me, not dies, not more than spirit dies,
> But in a change like death is clothed with wings;
> A serious angel with entranced eyes,
> Looking to far off and celestial things.

Yet I am going to mention a few plantation happenings that will go to show that life, even in the Deep South of old romantic days, was not all moonlight and camellias. Then,

as now, life everywhere is made up of roses and razorbacks, arsenic and azaleas. If it were otherwise, it would not be so piquant.

While I was living away from my plantation, my Negro foreman and caretaker wrote that he was badly in need of a mule. I purchased one for him, but it soon appeared that I had only half supplied his longing. He wanted a wagon to go with the mule. Then, as he put it, he would have "real transportation."

After lengthy negotiations I at last bought a wagon from a mail-order house, and as any freight sent to the plantation had to go by rail and boat, specific directions for the shipment of the wagon had to be given. The first delay occurred when the firm in Pennsylvania shipped the wagon to me. After much loss of time, due partly to the low-gear speed on Southern freights, the wagon was reported to me as having arrived within ten miles of the plantation. I knew my foreman would ride the mule down to this place, proudly hitch him up, and drive him home in lordly manner. I fancied the picture they would make.

A few days later, however, this devastating word came from my caretaker: "Dear Cap'n, the day before the wagon came, the mule died."

One very cold winter's day my Negro foreman, Prince Alston, and I were ferried across the Santee River by old William Jenkins, who told us that the night before he had lost by fire his cabin and all its contents.

I expressed due solicitude and told William that I would send him something toward the building of another home.

Prince, however, went right to work on the business of a new residence. On account of the weather, he had on a half-dozen shirts and sweaters. Long and sedulously he fumbled amid his voluminous clothes. Finally he produced a nickel, and presented it to William with no apology, and with a forthright generosity that touched me. I had reason to believe that it was all the money Prince had, and perhaps had had in weeks.

William was equal to the occasion, accepting the gift with unfeigned gratitude. When you have nothing, five cents looks like a fortune, in this case it was a Beginning. I cannot recall any other experience that reminded me so strongly of the Widow's Mite.

On my Carolina plantation, during the summer of 1886, Will, our handyman, was paying more or less violent attention to Martha, our cook. Martha lived alone in a cabin in our yard. August 30 had been a singularly hot and oppressive day, yet Will chose that night for proposing. Really, the only objection that Martha had to him was that she suspected him of loving the bottle—a tendency that might eventually lead to his preferring the bottle to her.

As would be natural for any woman, Martha knew that this was The Night, perhaps even before Will did. She arrayed herself accordingly, and sat demurely awaiting eventualities. Only a low light burned in her cabin. She was happy yet uneasy, for she feared that Will might have bolstered himself for his romantic adventure.

The first thing Will saw on entering the cabin was a big bucket of cold water standing on a table by the door, an inviting gourd beside it. Before saying anything, he dipped

up a gourdful of the water. Martha watched him suspiciously, hoping that his hand would not tremble, yet not unwilling to experience the sinister joy of having her fears justified.

Will's arm, hand and the gourd began to perform weird circles, tossing water incontinently all over the table and the floor.

Martha calmly reached for a broom, stood up in her wrath and then made a rush at the apparently drunken miscreant. Will fled, his dream of love blasted by an act of God. For then the house cracked and swayed, subterranean thunder shook the earth, wild cries of dismay went up from all over the plantation, for it was the great Charleston earthquake, the most severe convulsion of nature on the eastern seaboard within recorded history.

When it was all over, Martha was willing to relent, but she said grudgingly, "I 'spect he was drunk anyway." Then she added quaintly, "But I will marry him on account of the earthquake."

The match was, humanly speaking, perfect over a period of forty years.

About ten miles south of my plantation is the vast and forbidding wilderness known as Hell Hole Swamp, notorious almost since the Revolution for bootlegging, highjacking and murder. Yet it is a lovely place, and it is the home of the remnant of the French Huguenots—wild, lawless, ignorant, intelligent, proud, lovable, and dangerous people. Not long ago four of these backwoodsmen came to invite me on a deer hunt. They have been my friends since boyhood.

As we were sitting on the front porch talking over old times, up the avenue came a glittering car, and out got some glittering people—four members of the high English nobility. For a moment I thought I was on the spot, for what was I to do with the titled lords and ladies and the Hell Hole boys? Yet I remembered a remarkable thing: these Huguenots, whatever they may have lost, have retained social grace; they have the instinct for doing the graceful thing. They have never heard of Emily Post; but if you ask one to your table, although he will look like a werewolf, he will know which fork to use. Marvelous storytellers, they have the delicate gestures of Frenchmen, and they can imitate the voices and the behavior of wild creatures.

I introduced everyone with due ceremony, and we formed a big circle on the porch. Then the backwoodsmen, with native genius, did what they could do best: they told hunting stories! For a half hour they entertained us royally.

When they were gone, one of the English patricians said thoughtfully, and with a light of recognition and appreciation dawning in her eyes, "Now we English understand what you Americans mean when you talk of Daniel Boone and David Crockett."

She had recognized the worth of my Hell Hole friends. And is not that what genuine democracy means? Does it not always mean, in its best sense, the power to discern and the grace of heart to pay tribute to the virtue in the other fellow?

In these days of meat shortages and other exigencies, it

is an important thing to bring home wild game. As my home is in the wilderness, I have a good many opportunities thus to declare my independence of shortages without invading the black market. Perhaps the most remarkable example of pure luck in killing a huge wild gobbler that I can recall occurred recently.

Early one warm winter morning I was out in the big field in front of the plantation house. My wife came out on the front porch and rang the breakfast bell for me. As if in response to the summons, an old wild gobbler sounded off from the riverbank, about three hundred yards behind the house. Detouring through the house to pick up my turkey call and my gun, I hurried to meet him. My call, by the way, perfected after some twelve years of experimenting with more than twenty kinds of woods, is a fatal thing. I call it Miss Seduction. A gobbler can't take it; when she calls, he just collapses emotionally.

A fine human psychology governs the calling of a wild turkey. The absolutely fatal thing to do is to call too much (every woman please note). A gobbler is a patrician of the wilds, and if I call too much, he will not come. He is not afraid; he is disgusted. He says, "That's that same girl after me again." But if I call only once or twice, then his imagination takes fire. He's just like a man, and he says to himself, "Could it be, after all these years, that I am to meet at last a wildwood princess, shadowy in her avoidance?" And he'll come, and usually running.

I did not go fifty yards beyond my camellia garden before I sat down behind a stump and gently vamped this old aristocrat. Five minutes later I collected him—twenty-two pounds of him. Nor are there many things that will

more infallibly redeem a husband in the eyes of his good-housekeeping wife than to see him bringing in one of these regal birds. In this case we called him to breakfast, and then invited him to stay to dinner.

Tyler Somerset, that prince of backwoodsmen, whose lonely bailiwick is Hell Hole Swamp, told me this story about some of the Negroes on my plantation.

"I knew of some wild hogs that we might catch and fatten for Christmas, so I got Steve and Paris and Old Testament to come out to my place one day to help me round them up. I had five dogs, and each of them brought a dog, but their pack looked as if they had coyote blood in them. At the very beginning I made a mistake. I told them of a wild boar out my way that was as big as a half-grown mule, and that could swing a bull alligator around in the air on his tusks. After I said that, they seemed to lose a good deal of interest in our hunt.

"But after a while one of their curs stirred up an old raccoon, and he got into a kind of a cave in a bluff that had a very narrow opening. For some reason the dogs would not go in. To my surprise, Old Testament said he would go in if he could keep the raccoon for himself. His wife, Amnesia, had hinted to him broadly that he had better not come home empty-handed. Into that place this old Negro crawled, at the same time telling us to keep away from the opening so that he would have some light.

"No sooner was he fairly inside than my dogs jumped what I thought must be the big boar from the way they yammered. I said as much to Steve and Paris, and the next thing I knew, they had climbed trees, and were draped

from the upper limbs. In the cave, Old Testament could not hear what we were hearing. In a minute or two, the bushes broke, and a black bear came r'arin' out, heading straight for that hole in the bank. I yelled to warn the old man in there, and his two friends called good-by to him.

"The bear was bigger than the hole, and as he started in, he got stuck. I got him by the tail and braced my feet to hold him, at the same time yelling to Steve and Paris to come help me. It was as if they had not heard me. From the dark cave I heard Old Testament: 'Who done darken dat door?'

" 'Old man,' I shouted, 'if this here bear's tail ever pops, you'll know who's darkening the door.'

"About that time the bear pulled back, and my dogs crowded him. Then something shot by me, and it seemed to land without any effort in the fork of a gum tree. It was Old Testament. He was looking reproachfully down at me.

" 'No b'ar been in dis bargain,' he said. 'He's in a class with Amnesia.'

"We didn't get a raccoon, a hog, or the bear, for he was too much for my dogs to handle. And I haven't been able to persuade your men to hunt with me since."

My father's story I have already told in *My Colonel and His Lady*. But I did not tell much of his Negro friends and of his relations with them. Born on a slaveholding rice plantation in South Carolina some twenty years before our Civil War, he knew slavery, emancipation, reconstruction and the years that followed. As he lived until the year 1922, he had had ample time to observe Negroes of several generations and under radically changed conditions.

He loved his colored friends, and they loved him; and although he has been gone for more than two decades, old Negroes are still stopping me on plantation roads to talk about him, to quote him, and to identify him with a happier day than ours. Experiences of this kind impress me with the fact that love thwarts time, and that insofar as human relationships are concerned, there is no substitute for affection, for where true affection is, no thought of *rights* or of *equality* ever arises. And I have been impressed also with the thought that, for all our so-called advance, the people of the past, in some most essential matters, knew more about life than we do. They seemed able, for example, to build things permanently. They even made marriages last.

Especially when he was old, and when the thought that he might soon have to leave me was heavy upon him, my Colonel, wanting to make sure that in the years to come I would not fail fully to appreciate his meekhearted friends of the plantation fields and woods, would often call my attention to things they were saying and doing, had said and had done. He had a ready and infallible eye for what was admirable in expression and in action; and I never knew him perversely to withhold his open approbation of something fine. These withholders of admiration are, as a rule, afraid that praise of another will diminish their own importance.

Here are some Negro sayings that especially appealed to him, and he recommended them to me.

One night a Negro had been frightened near the graveyard by a sound he did not understand. When asked what

he did, he replied, "I take my hat in my hand, and I say, 'Foot, help de body!' "

As to a man's roaming proclivities, this sage bit of philosophy was forthcoming: "Woman and cat should stay home; man and dog should go abroad."

When a Negro said he had had a close brush with the law, another asked, as if he were amply insured against such exigencies, "How, ain't you got yo' two foot?"

"If you play with a puppy, he will lick your mouth" is evidently a warning against too much familiarity, especially with inferiors. And "Prayer never gets grass out de field" evidently preaches that faith without works is vain.

"If you knock de nose, de eye gwine cry," has the meaning that if you injure one of a family or clan, all will suffer.

Great, indeed, was the excitement on the plantation when it was discovered that Old Cudjo had received a legacy, or, as he insisted on calling it, "a fortune." There is always a very natural interest attaching to a legacy, and this was much increased by the fact that Old Cudjo seemed the last person likely to receive one.

He had long been one of our plantation charges. Without family or relatives, as long as I could remember he had lived alone in a small cabin that my father had had built for him at one end of the Negro "street." To us he had always appeared too old to join in the regular work of the plantation, but he cut a little wood, raked leaves, mended fences and was generally handy. Every Saturday, regardless of the amount of work that he had accomplished during the week, Old Cudjo was apportioned his week's rations. This way of his life continued for many years, indeed, until

the magic word came that a distant relative in Georgetown had died, leaving the old Negro a legacy. The word, traveling by rumor's short-cut route, came before the letter from the attorney in Georgetown reached my father. The letter contained the official announcement of Cudjo's bequest, and likewise enclosed a check for the full amount of the legacy.

Well I remember how (while Old Cudjo, who had donned his best clothes in celebration of the event, and was waiting in the kitchen to receive his fortune) we were amused, disappointed, and concerned over the contents of that letter! The lawyer wrote bluntly that a Negro had died, leaving a sum of money to his "Cousin Joe," and the lawyer had learned that Old Cudjo on our plantation was the legatee. He was therefore enclosing his check for the full amount. And the check—the fortune—was $14.35! We thought at first that we had a most delicate and difficult affair on our hands, for surely Old Cudjo would be sorely disappointed at the exceedingly modest size of the legacy. But Father took a different view of the matter.

"Old Cudjo," he said, "knows nothing of money. This will be a fortune to him. We need not show that we are disappointed; then he will be perfectly happy. All we have to do is to congratulate him and to advise him to spend it wisely."

It was therefore in this spirit that we told the old Negro of the amount of money which had been left him, and he was quite as overcome with gratitude as if the check had been one for four figures. There was no sign in his attitude which showed that he was anything but profoundly moved by joy and pride. And it was while Old Cudjo was in this

thankful mood that my father broached to him the matter of the disposal of the money.

"Now, Cudjo," he asked, "how are you going to spend all that money?"

The old Negro did not at once reply. He shifted his weight uneasily from one foot to the other, and in his eyes a strange light shone. He looked as if he feared that his announcement would be too ambitious to please us. At last he cleared his throat and spoke the word.

"I is gwine to buy a mule," he said with finality.

"A mule, Cudjo?" Father asked kindly, while the rest of us were trying to suppress our smiles. "Why, Cudjo, I'll gladly lend you one of my mules for any work you want done. How could you make use of a mule?"

Cudjo mused for a moment. It was clear that his decision was made.

"I done love a mule so," he said at last, musingly and pathetically, "and I ain't never had one. When I go to church," he added, "my mule would be my transportation."

We had been afraid of some determination of this sort, but we had hoped that it would not be so unreasonable as this. Old Cudjo had no land, he had no stable in which to keep a mule, he had no feed or forage for it; if he wished to drive or ride it, he had no buggy, wagon, harness, saddle or bridle. Besides, we were doubtful if he could buy any kind of live creature for the small amount of money with which he had been endowed. But though we seemed to have all the reason on our side, the ancient Negro had determination and a strong natural desire on his. In short, our wishes and urgent advice to the contrary, Old Cudjo

had his way. It was no later than the following day that several of the Negroes told us that the legatee had taken his "fortune" and had gone to Charleston to buy a mule. The whole affair, though somewhat pitiful and ludicrous, well illustrated the weakness to which human nature is sometimes liable.

For a few days we almost forgot the incident of Old Cudjo's legacy. But we were reminded of it one morning when Prince came up with the news that Old Cudjo had returned from the city. "And he done bring dat mule," Prince added in a shamefaced way.

My brother Tom and I had been making some bird-traps under a big live oak in the backyard when Prince approached us with this diverting piece of news.

"What kind of a mule is it?" Tom demanded.

"A white mule," Prince said, "and he is sick. He walks like dis," he went on, taking a few high, wobbly, ridiculous steps.

"What is the mule doing now, Prince?" I asked.

"He is lying down. And maybe he won't get up no more!"

"Let's go over to see him," suggested Tom, seeing an opportunity not to be lost.

Prince and I only too readily assented, and together we set out for Old Cudjo's cabin.

Long before we reached it, we saw that there were many others on the plantation attracted by the same impulse which was leading us across the rice-field banks. About Old Cudjo's cabin there was a great crowd of Negroes, large and small, and the crowd swayed and tiptoed as if it were viewing an accident. Indeed that which it saw was some-

thing resembling an accident. The crowd parted as we
came up. As the dusky faces turned toward us, we saw a
marvelous assortment of expressions, but the prevailing
one was one of amusement. Evidently those who had
envied Old Cudjo and his legacy were now beginning to
feel that his good fortune had not, after all, created be-
tween them that gulf which is usually fixed between pov-
erty and affluence. But for the smiles, we felt the
atmosphere to be decidedly funereal; we felt as if we were
being privileged to step forward "to view the remains."

In the open space before Old Cudjo's cabin sprawled
the object of our quest. Emaciated, fatigued, lugubrious
in countenance, it seemed fully prepared to fulfill Prince's
prediction that it might never rise from the place into
which it had now subsided. Near the head of the mule
stood Old Cudjo, like a showman proudly exhibiting the
chief spectacle of his menagerie.

"Where'd you buy him, Cudjo?" I asked. I meant to be
kind, but this was an unfortunate question. The Negroes
all about me began to grin and chuckle. There were many
answers murmured, some of which I caught: "Somebody
done pay him for haul it away"; "He done find him in the
graveyard"; "Dat is the mule Baalam done ride a thousand
years ago."

Cudjo, not in the least conscious of his mule's evident
shortcomings, told us that he had not been all the way to
the city, but that, making his want known along the road,
he had found a man who was willing to part with a mule.
The man, he said, was a very kind gentleman to let him
have the mule for $14.35. We thought the gentleman to
be a shrewd bargainer, to say the least.

By this time the Negroes had begun to disperse, and since we were eager to tell the people at home of Old Cudjo's purchase, we started back toward the house, advising Old Cudjo to come up to the plantation stable to get a good feed for the mule.

When we told Father how the Negro had spent his money, he was plainly distressed. He did not see the amusing side of the situation as we did; at least it did not impress him so strongly as the pathetic one. I think he felt that he should have taken the whole matter into his own hands, and should have insisted that Old Cudjo spend the money judiciously. Indeed, this persuasion grew upon him to such a degree that that night, while Tom and I were still laughing over the desolate appearance of the mule and the sly remarks of the Negroes, Father told us that he was going to make Old Cudjo take the animal back, and that he himself would go with the Negro to help him recover the money.

"What if Old Cudjo objects?" Tom asked.

"I can make it clear to him," Father replied, "that he has been swindled."

"What if the mule refuses to get up?" I put in. "He may have to be taken back in a wagon."

"He will get up when he sees something to eat just out of his reach," Father assured us.

Our bedroom was on the first floor, but since the plantation house had a high cellar on a level with the ground, our windows were some ten feet up. Ours was a corner room, with four large windows, and we always felt that we were especially easy of access from the outside. On account of this, we had an understanding with the Negroes on the

place that if any of them needed us in the night, or brought a message of some kind, he should come to one of our windows and rap with a long stick. Then, if necessary, we could awaken the others in the house. As the years had passed, we had grown accustomed thus to be frequently awakened. Sometimes a Negro would come for some medicine for a sick child (and then we always awakened Mother); sometimes a message would be brought from a distant plantation. Often Prince would come, just to tell us to be ready for some exciting adventure the next day. On this particular evening, therefore, we were not at all surprised to be awakened by a rapping at the wooden shutters of our eastern window. Tom and I thought we had just gone to sleep, but as we came to the window we saw that the sky was rosy through the dark glossy foliage of the live oaks and through the pendant banners of moss that they bore. Beneath the window we perceived in the dimness the customary dusky figure.

"Is that you, Prince?" Tom called.

"No, sah," came the answer in a sad voice, "this is Old Cudjo."

"What's the matter, Cudjo?"

"My mule—my mule is done died!"

"Dead, Cudjo?" I asked. "Are you sure?"

"That fool mule," he answered, with a wholesome note of resentment in his tone, "done kill heself."

Then he told us that, after we had left his cabin, the mule had got up, had grazed in a near-by grass field, and had apparently been all right. He went on to say that at dusk he decided to tie up his "creeter" for the night. He

had therefore led the mule near the cabin and had tied him to a small persimmon tree that stood in the yard.

" 'Bout an hour ago," Old Cudjo ended, "I heard a pitching and a jumping and a wrastling, and when I got out the door to that fool mule, he done been hang heself."

"Oh," said my brother slowly, a sudden thought dawning in upon him, "so the mule hanged himself, did he, Cudjo?"

"Yes, sah, dat's what he done do."

"How did you tie him? What kind of a knot did you use?"

"I done tie him very careful, sah; I tie him with a *good slipknot round his neck;* but he done hang heself."

My brother and I withdrew from the window for a moment to get control of ourselves out of sight of Old Cudjo. In fact, I never did go back to the window. I lay on the bed and laughed in the most shameless fashion. Tom talked for a while with the old Negro, gave him some comfort in the shape of a piece of tobacco, and assured him that we should be over to his cabin to see him in a short while. When we did go, a half hour later, we found that the old Negro's story was perfectly true, even to the disastrous detail of the "good slipknot."

Thus perished the "fortune" of Old Cudjo. But the ancient Negro bore his loss like a philosopher, and his strong resentment against his mule for hanging himself relieved the situation from any very tragic element. Moreover, his grief was assuaged in other ways. One day we overheard him say to Father: "I done had a mule once in my life, and that is something to be thankful for. And if

that mule had lived, he might have made me proud, sah, and you know I ain't nobody to be proud."

Far be it from me to attempt to explain the Negro's love for a mule, but the affection is there—occult, profound. A plantation Negro who went to Detroit to work returned after some years, his disillusionment complete.

"Nobody in dat town," he said, "ever names the name of God, and I *ain't never seen a mule*."

Few human beings feel entirely at home except where they were born. This trait is especially strong in the plantation Negro, who cannot be easily transplanted. Away from his pines and his sandy roads and his unconscious deep communion with the spirit of nature, he feels his religion slipping from him. I once heard a Santee Negro say, of certain prayers he had made while on a visit to Charleston, "In de city, my prayin' ain't got *no proper suction*."

While the Negroes on Hampton seldom went more than a few miles from the place, on one occasion Martha went to visit in Georgetown—a prodigious distance of fourteen miles. They are at home in the dim fastnesses of the great sighing pine forests, and they know with psychic penetrance the life of field and forest, knowing the birds, the animals, the plants, wise with an ancient wisdom, pagan, if you please, but, thank God, authentic. Their voices are the voices of natural culture, having in them the tones and the colors of the plantation birds, and the wild blossoms and the choiring seawind that loses itself in the fragrant fastness of the dim sweet plantation wilderness. After hearing modern American voices, by plantation Negro voices

one is instantly charmed, and then made slowly to feel that, after all, life can, even in this hoofhearted age, be a gracious thing. With utter candor I will say that I am deeply their debtor in a spiritual way, for they renew a right spirit within me. They can do this because they seem to me to have mastered, with an unstudied humility and therefore with certainty, the philosophy of living.

The brilliant though eccentric John Randolph of Roanoke, after a long and discriminating public career, turned wearily at last for relief, and turned not in vain, to the Negroes on his old Virginia place for companionship, and for that oriental peace of heart, the fruit of calm resignation.

Through all the years, from boyhood days, I have trusted Negroes. And I have never had reason to repent me of my faith, which some of my neighbors considered poetically extravagant.

> They have most power to hurt us whom we love;
> We lay our sleeping lives within their arms.

In a real sense I laid my sleeping life in dusky arms, and they cradled it with that sagacious and unselfish tenderness that we call true love.

It was partly through the influence of Negroes that I came to have a sense of the mystery of nature and of life. I thrilled when I heard them speak of "de elements"— those mighty primal forces, which, though vast and apparently insensate, are nevertheless under infinite laws. They made me feel the lyric rhythm of the seasons, of the tides, of the sun and moon and stars. They helped me to identify myself with the universe.

It sometimes happened that the whole plantation was called on to hunt down some especial marauder. Such was our exciting search for and the final killing of a great wild boar which had come down to the plantation during a period of high water in the Santee. In the mighty and, for the greater part, unexplored Santee swamp northward from our place there are wild boars of formidable size and ferocity. Certain hardy woodsmen who hunt in the swamp have told me that they would rather encounter any other wild animal than one of these savage tuskers. When the swamp would become flooded by a freshet, these brutal marauders would usually take refuge on the high pine ridges by which the swamp is traversed. But this particular boar swam downstream—and there are few better swimmers than a hog—and came to land somewhere along the marshy borders of the plantation. The first information that we had of his unwelcome visit was the disappearance of two of the hounds. Then one of the Negroes reported that his dog had likewise disappeared, and a second found his dog terribly crippled and trying to drag himself home through a cotton field. Old Dolly Wethers, an aged Negress, who used to go out in the thicket margins to get firewood, reported that she had seen a great gray shape, silent and ghoulish, gazing at her from the semitwilight of a myrtle thicket. All these matters made us aware that we had a strange and menacing prowler on the place. Then Scipio found his track, and as Scipio was a hunter of no mean ability, we believed his word that the creature was a wild boar.

A hunt was accordingly organized, and such a motley collection of dogs and hunters and hunters' weapons you

never saw. The dogs were of all kinds and of all degrees
of social standing, from a noble bloodhound down to a
plain woolly dog belonging to Scipio. The hunters were of
many ages; my brother and I and a pinelander named
Snyder were the only white men. There were several guns
in the crowd, but most of us carried scythes, pitchforks,
axes, and even hoes and rakes. We looked more like a
crowd of fieldworkers than a band of grim hunters. To the
river edge we set out, the men with the guns in the lead.
The dogs followed in the order of their enthusiasm; the
old bloodhound was not at all sure about mingling in such
mixed company.

On an old bank running parallel to the river the dogs
took up the trail, and soon they were in full cry. We took
a wide semicircle to intercept the boar if he tried to make
a break for the pinelands. But our caution was needless.
Far down in a gloomy covert near the river the multitude
of dogs brought the minotaur to bay. He was in the edge
of a canebrake, and the dogs were so numerous, and some
of them were so smart, that the grim old raider couldn't
get away from them. Most of the hunters were content to
stand on the bank. Some of us moved cautiously down
toward the brake, where a tremendous uproar told plainly
enough that a savage fight was in progress. Scipio, the
hunter, reached the scene first, and, discovering that the
boar was laying out the dogs right and left, he let drive a
charge of buckshot from his ancient but reliable musket.
This shot felled the boar. When I came up, the huge and
dreadful beast was dead. About him, scarred and bleeding,
were the frantic dogs, snarling and yelping. Two of the

smaller ones lay quite still and sickly huddled against a cypress tree.

"They is done dead," Scipio told me. "He might have killed all same fashion if we hadn't come up. One of these," he added, putting his foot on the boar, "can fight and whip 'most anything but buckshot. He don't quite understand yet how to handle shot."

In barbaric triumph we bore the great brute out of the morass, and for a day of two it was the wonder of the plantation. Most of the Negroes hinted gravely that it was a token of supernatural manifestation. Six months later, when some of the stock began dying from anthrax, they took occasion to remind me of the boar's visit as a true prophecy of trouble to come.

One of the most amusing and characteristic of my plantation adventures occurred when Prince and I were driving home to the seacoast village, after a day at the plantation.

It was in September, and there were hints of autumn in the air and on the heavy foliage of the lustrous trees of the swamps. It had indeed been a happy and fortunate day for us, a "day of plunder" as we used to call it. By this we meant that we were returning home with our buggy full of all sorts of good things for the family in our summer home in the near-by seacoast village. The plantation, where we were unable to live in summer, could supply what the coastal village could not—fruits and vegetables of many kinds.

On this particular occasion our buggy was loaded to the seat with a wonderful assortment of provender. Our own

plantation garden had given us three fine watermelons and more than a dozen cantaloupes; a neighboring planter had sent us over a big basket of scuppernong grapes and several pomegranates; while some Negro boys had brought us, from a swamp far up the river, more than a bushel of delicious big muscadines. Besides these fruits, we had a great quantity of all kinds of vegetables piled high in front and behind the buggy seat.

"I hope we are going to get it home," I said to Prince; "but you know we can never count on a mule. And this one we are driving is just like the whole tribe, only a good deal more so."

We had a lot of fun on that drive, and no mishaps occurred until we had passed the Five Mile Post. We had made good time and were well satisfied with the distance we had covered. The sun was just setting, and we knew we could get to the village before what the Negroes used to call "hard dark."

As we were coming down the road toward one of these thickets, whose gathered waters made a long "slash" in the driveway before us, the mule suddenly shied, snorting. We pulled her up short, and saw that she was trembling.

"Snake?" I suggested, for at that season of the year the pinewoods are infested with them.

"Let me look." And Prince handed me the lines while he eased himself out of the buggy.

Under such circumstances, the quickest and safest way to find a snake is to look for its trail crossing the sandy road. This Prince did, and soon I heard him whistle softly.

Taking a turn about the whip with the reins, I jumped out of the buggy and ran to where he was standing.

"Did you ever see the like!" he exclaimed. "And they don't seem to mind us at all."

Following the direction of his pointing finger to the growth of scrubby grass beside the road, I saw a strange-looking creature—black and white and tawny gold. Then I discerned that what lay before us was not a single creature, but two snakes in a woodland encounter. It was a fight, or the finish of a fight, between a king snake and a rattler, two of the most inveterate enemies in the whole wide range of the animal kingdom. The diamondback was a small one, while the thunderbolt was large and powerful, and this kind of fight, usually unequal enough, was here almost pitiful. I think the rattlesnake must have been dead when we came up.

From the coiled snakes, both Prince and I suddenly took a notion to glance up the road at the buggy. We saw the mule, her idiotic head turned all the way around, looking at us in her pleading, humorous, apprehensive fashion. Just then a gauze-winged deer fly must have bitten her, for the expression on her countenance changed suddenly to one of pained surprise. She turned her head, switched her rubberlike tail energetically, and kicked out somewhat tentatively with one foot.

"Let's get back," said Prince.

"Yes, we had better . . ." I began to say. "There she goes now!" I added, as the mule and buggy started down the long water slash.

We ran down the road cautiously, and as we neared the buggy, each one of us turned out into the woods, trying by following a little arc to surprise the mule and head her off. But she, having on blinders and hearing the gallberry

bushes crackling, beat her flanks briskly with her tail, cocked her ears amiably, and went splashing at a trot into the water. Nor did the natural resistance to her progress thus offered greatly slacken her pace. She went straight on. As she neared the farther side, one of the wheels struck the edge of a stump, jarring and tipping the buggy. Half a bushel of ripe tomatoes were tumbled into the slash, and went bobbing up and down on the turbulent waters. Having reached the dry land, the mule continued her pace on the road beyond and appeared in no way inconvenienced by our absence or moved by our cries, except that she seemed to take them as commands to show her stuff.

The swamp on either side of the road being practically impassable, there was nothing for us to do but to wade right in and cross the water, which fortunately did not come above our knees.

Every few minutes the wheels of the buggy would strike a root or a bad rut hole. Then it would lurch, sickly, and fruits and vegetables of all descriptions could be seen rolling and bounding out. I suppose some of these pelted the mule, which made her run faster. As we hurried down the road, we felt for all the world as if we were in a good hare-and-hound chase, for our course was plainly enough marked. But instead of bits of colored paper, the road was lined with beets, carrots, okra, broken watermelons and yellow scuppernongs.

The muscadine grapes, being under the seat and being comparatively small and light, were the last to go. But no sooner had the vegetables from the back of the buggy been distributed along the road than it came the turn for the fragrant wild grapes to guide us homeward.

A bend in the road hid the already distant buggy from our sight, while the falling twilight rendered the piebald objects which our runaway had distributed but dimly visible in the pine trash of the woodland road.

When we came up to the bend, the buggy was nowhere in sight. Not far from that point the road forked, the one leading far into the remote pinelands to the northeast and the other leading home.

We never thought, until we came to the forks, that the mule might not take the home road. But there we became decidedly perplexed. Several other planters, driving mules, had come on just ahead of us, and each had followed his own road. Consequently, there were fresh mule tracks and new buggy tracks in each direction. Besides, there was practically no light left, and the tracks which were visible were outlined but dimly.

Prince looked at me and I looked at him, and in the dusk we both were smiling, puzzled smiles, it is true, but still, smiles that expressed a comprehension of the humor of the situation. We had for so many years been close comrades that we never felt entirely dismayed at any difficulty, however severe, provided we could face it together.

"Has she gone down the Seven Mile, clear to Moss Swamp, or did she turn in here toward Islington, as she should have?"

"Being a mule, I might reason that she did the wrong thing, and took the Seven Mile Road. But, Prince, can't we find any grapes? They would tell us plainly enough. Let's see if we can't strike the muscadines' trail."

In the summer woods of the South, the muscadine grape is usually discovered by the aroma which it exhales. Of all

delicious wildwood odors, it is the most alluring. It is a fruit smell, but it seems a flower-fragrance too. It is richer than the sweet bay, spicier than the yellow jasmine, and as aromatic as the blossoms of the fox grape or the scent of the pine needles after rain. It was for this odor and the sight of these grapes that Prince and I were now on the alert. I took the Seven Mile Road, and he took the road leading toward the village.

Soon, across the narrow strip of dark woodland separating us, I heard Prince's laughing voice: "Here's the wine, Cap'n."

When we were well on our walk toward the village, he told me that he had not actually seen any grapes, but that their fragrance had been so convincing he had felt justified in calling me over.

Through the lonely woods we passed, coming at length to Islington Place, a big turpentine farm along the road, where, as we expected, our mule had been stopped.

We found the buggy and harness intact, but the body of the buggy was as empty as a dry eggshell.

I have always loved to discover and to reveal obscure fealties. Of these, none ever appealed to me so much as the incident of Will and the bride's trunk.

In the days before cars, whenever a visitor to the plantation was traveling with a trunk, it had to be brought by boat from Charleston to McClellanville, and from there hauled ten miles in a wagon to our house.

One Christmas a bride and groom were to spend their honeymoon with us. It fell to me to arrange for the safe transportation of the precious trousseau trunk from the

steamer wharf to the plantation. For this critically impor-
tant commission I enlisted the aid of Will, I tried to impress
on him the great and vital importance of the business. And
as the weather was threatening, I enjoined him not to let
the trunk get wet. "Whatever happens," I told him, "be
sure to keep the trunk safe and dry."

After some hours Will not having reappeared, and a fine
rain beginning to fall, I mounted a horse and rode forth
to meet him. Old, not especially bright, painfully deliber-
ate, he was yet almost tragically faithful, as you will see.

Two miles from the house, on a broad straight reach of
sandy road, I came upon the horse and wagon standing still.
By then a black winter rain was deluging everything. At
first I could not see Will. When I discovered him, he was
lying flat in the bed of the wagon, face-down, covering with
his body a broad crack between two boards. On the dry
sand under the wagon was the trunk, over which Will had
carefully spread his overcoat.

When he found me beside the wagon, he turned his
streaming face to me and smiled: "You say the Lady's
trunk must not get wet," he explained simply.

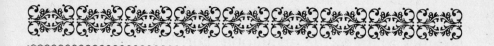

Chapter 3
Dusky Dilemmas

WHEN a white man like myself lives far back in the unchanging wilderness of the Deep South, and has more than a hundred Negroes to whom he has to be a lawyer, doctor, financial agent and general father-confessor, it is inevitable that they should bring to him (as they bring to me) for possible solution some of their baffling human problems. Since it is not in my nature to feel Olympian or, like King Arthur, "throned and delivering doom," I have never been certain of my success as an oracle. Nor am I at all sure how many of these problems represent a desire for excitement; some possibly are presented just to test my supposed infallibility. But, whatever the motives may be, my Negroes assuredly lay some curious cares in my lap.

The whole business of government, especially the unpleasant detail of taxes, is to a plantation Negro a dark and mysterious affair. It's just one of those things that white men invent to take the joy out of life. At least once a week at any time of the year a Negro will come to me with the bleak announcement, "Dat tax man done run me down." There is usually in his tone a tinge of personal grievance against me, as if I were responsible for his plight, for I, as a white man, must have something to do with making the laws, especially these nuisance statutes having to do with taxes.

When Jim Washington walked seven miles on a very

55
39225

cold day to see me, I had an unworthy suspicion that what
had brought him was something other than a longing to
lay eyes on me once more. Sure enough, after some bland-
ishments had passed between us, Jim began a telltale fum-
bling in the bosoms of four or five ragged shirts he was
wearing. Out he drew the inevitable pronouncement from
the sheriff that if he did not pay his poll tax, his place would
be sold. The South Carolina poll tax is $1.00, but if one
does not pay it promptly, it mounts magically. Jim's was
$6.50, and it had been overdue only a few months. I some-
times think that the amount of the poll tax depends on
how much the collector needs—in the same sense in which
I recently had revealed the esoteric system of voting in
Charleston. A Charleston candidate was making a very
close race. His opponent had piled up some prodigious
opposition, and was reported over the radio to be actually
in the lead, "but Charleston hasn't yet been heard from,"
the announcer added.

Said one of the boys, politically wise, who was listening,
"Charleston is going to wait to report until she sees how
many votes she needs."

In a case like that of Jim's I am, of course, supposed to
pay the tax, and Jim will "work it out." I have found this
system a snare and a delusion. Yet I can't let the sheriff sell
Jim out. As usual I assumed the white man's burden. In
writing the sheriff I explained that my check was to cover
the tax, with myriad penalties, of "poor old Jim Wash-
ington."

A few days later I got a letter from the sheriff in which
he asked me how old Jim was. If he happened to be over
sixty, he did not have to pay this particular tax.

Immediately I summoned Jim, to question him about his age. He did not have any idea about it at all.

I then said, "Jim, can you remember anything especial that happened in your lifetime, and about how much grown you were when it happened?"

For some moments his countenance was blank. Then suddenly it brightened. "I had good sense," he told me, "at the time of the Great Shake."

Immediately I understood his meaning, and I could estimate his age. To "have good sense" a Negro child must be six or seven years old, and the Great Shake, of course, was the so-called Charleston earthquake in 1886. (I've always been a little dubious of the advertising advantages of a city's claiming an earthquake.)

I wrote the sheriff that I estimated Jim's age to be sixty-three, and he returned my check, a fact which solved two pressing problems: one was that Jim was wholly freed from the poll-tax nightmare, and the other was that I recovered my outlay.

Young Sam'l, aged about twenty-seven, is a smiling young Hercules, so built that I have always thought he might be developed into a worthy opponent of Joe Lewis. With the women Sam'l is quite irresistible. I knew, in a vague and general way, of some of his conquests, but I never expected to be called upon to solve one of his triangles for him. Yet one day he brought me his difficulty. There was a girl in Moss Swamp, it seems, who had a child by him. The child then was five years old. He had a girl at Collins Creek also. Just before coming to me with his cares, Sam'l and these two claimants upon his affection met, by

great mischance, at a dance. And as he put it succinctly to me, "There was some hair pullin'."

What he wanted me to decide was which girl he should marry. The first one claimed him on account of the child, the second one, assuming the role of a great lover, declared that she loved Sam'l more than her rival did. As for me, I stalled for time. Who was I to pass judgment on love affairs? I'm not even related to Dorothy Dix.

"Well, Sam'l," I asked, not wishing by hesitation to show that I was in the least doubt, but really finding no footing at all in these deep waters, yet wading right in, "which one do you love more?"

Sam'l gave a slow infectious grin, thoughtful and appraising.

"Cap'n," he said, "as for me, I don't love neither one!"

During these recent years, the government has taken an active interest in the private citizen and his business, and my Negroes bring me endless papers to fill out, whether they have to do with applications for work, or for payments for cotton that they did not plant this year (and never have planted at any time). Many of the questions on these blanks touch on intimate matters such as, where and when were you born? I repeat the question, and try to get the answer down correctly. But I am often set back by answers such as these:

"I born upstairs, sah."

"Pa say I born dat same winter he done kill de big yaller sow."

"I born on a ebbtide, in de dark of the moon."

Sometimes I raise with a Negro the moral propriety of

accepting from the government money for not growing crops, but I never get to first base on that. To him the government represents the spirit of infinite wisdom and benevolence, and not to accept its gifts would indicate ingratitude, tinged perhaps with irreligion.

Occasionally a problem is not brought to me, but I run into it. I went head on into one recently. A group of Negroes, having knocked off work for dinner, were drooped and draped over the steps of the old kitchen in the yard. They are positively superb in the art of utter relaxation. But, while they literally disjoint themselves physically, mentally they have a grand time debating deep stuff, and bantering one another. As I came up, they were holding a high argument on the darksome question, Ghosts or No Ghosts? Since some would have to pass the old graveyard on going home at dusk, they could not enter this discussion with a blithe and carefree spirit.

"If ain't no ghosts," said Alex, "what done snort at me dat same night when my ox done balk, even though he done know feed been in he stall at home?"

Steve laughed.

"When you done hear dat snortin', Alex, what you do?"

"Ain't I done got my two foot?" asked Alex, intimating that the Almighty had supplied him with a way to escape ghosts.

"I don't rightly b'lieves in dem, but even so I don't doubts dem," put in Prince sagely, playing safe.

I had noticed that Isaiah, usually a great debater, had remained silent, and I could not tell whether the subject was distasteful to him, or whether he was meditating some

mighty argument that would make all the opposition fly like chaff before a whirlwind. Finally the oracle sounded off.

"How come you can say no ghosts?" he asked. "How 'bout de Holy Ghost?"

This ended all debate and brought Isaiah considerable, if momentary, distinction.

My Negroes' most constant business activity is borrowing money from me. And their appeals usually leave me financially disheveled. Either from ignorance or from deep sagacity they rarely offer any collateral. However, one day here came old Gabe down the avenue that leads to the house. He had in tow what is known in my country as a runt bull; it's a bull that started to grow but forgot to keep on. This woeful little creature was no bigger than a strong calf, but he had the sad aspect of maturity. When arrivals like this one occur on the plantation, I know that something is cooking, and it was so in this case. After some general remarks with old Gabe, during the course of which he artfully tried to get me to say something complimentary about the miserable captive he had led to me, he suddenly broke out of his ambush and said that he just had to have ten dollars, and that he would leave the bull with me as collateral. Since I had no pressing need for any kind of bull, especially the kind he had brought, I tried to save myself by prolonging the discussion. I made invidious remarks about the creature's general air of dejection, and about the absence in him of any social background. I finally went so far as to ask Gabe bluntly if he even owned the bull. It was a chance shot that struck home.

With considerable details he went into the bull's past, all the time elaborating his own scrupulousness, but casting some slight but essential suspicion on "my boy George," who, according to Gabe, had "found" the bull in the woods. But, after all, it was somebody else's bull in somebody else's woods. Nor was that the only painful disclosure.

"I always deal right by you," Gabe declared, "and I must tell you dis bull done already got a first mortgage on him. What I would like you to take is de second lien."

Well, Gabe got his ten dollars. Would you like to take a third lien on an utterly worthless runt bull?

Where I live on a river, in a wild and lonely country, there is much illicit whisky distilled in my neighborhood. I never pay any attention to this activity unless it invades my own property. On quiet nights from my back porch I can hear work going on at the stills up and down the river. Perhaps this occupation is not wholly bad, for it supplies a good many revenue officers with steady work.

My plantation Negroes have the greatest grapevine telegraph known to me. Soundless, it is as effective as the drums in Africa. They know everything that happens long before I do, and it often seems to me that they know everything that is *going* to happen. But they are exceedingly cagey about telling anything on a white man. As a rule, if a Negro thinks I ought to know something about a white man's trespasses, he will not come to my house to tell me. He waylays me in the woods to give me the information.

One day driving down a plantation road I heard a most peculiar sound from a dense sweet-bay thicket. Since in

that country I can never tell when I may see or hear a deer, a wildcat, an alligator, or any of a number of other wild creatures, I stopped the car to listen. After a little while I saw a bush tremble. Then Isaiah stole forth on feet that would make a stalking cat's seem noisy. He had seen me, and he had made sure that I was alone. But now he wanted to be certain that no one would see him talking to me. I knew from his attitude that he had something to say about a white man. The news, however, was not especially disturbing. While hunting hogs just across the river from my house, Isaiah had come upon a freshly built still. It was all ready for its first run. He cannily mentioned no names, but his hints were such that they infallibly identified the owner. After he had told me what he thought I should know, he did not follow the road home. He sidled away through the brush as warily as a suspicious old buck.

A dark dilemma had presented itself to him; he had brought it to me to solve. He had discovered the trouble; I had to deal with it. I did so by driving straight to the home of the still's owner. He's an old and a tried friend of mine. I told him what I had found on my property and asked him, if it happened to be his, to move it. About two hours later from my back yard I heard a resounding racket from across the river. The still was being dismantled. In order to keep his part of the affair shrouded in mystery, Isaiah did not come anywhere near me for a matter of three weeks.

The Negroes on my place and I have so many interests in common, and have so good an understanding that I do not recall more than one instance in which one of them

spoke to me impertinently. And since this offense was committed by a foolish boy named Shoofly, I never paid any
attention to it. His father, however, was stricken with
pangs. At first I did not know what his feelings were; I only
knew that he was dying to get something off his chest. It
did not seem likely to me that a man with the character of
Simeon, father of Shoofly, would continue the dispute. He
was in reality, as I surmised, framing a magnificent apology
for the behavior of his son.

One day he met me coming round the rice barn. This
was it, I knew, even before he spoke. A Negro often speaks,
especially to a white man, with no preliminaries.

"Cap'n Arch," said Simeon earnestly, "you must know,
sah, dat ever you see a nigger wid a raccoon head, he ain't
got no sense."

Thus deftly and succinctly did the father apologize for
the son, at the same time calling attention to the probable
source and cause of his shortcomings. In this case a problem
was brought to me and solved for me. My only part was in
accepting it with full assurance of its honest naïveté.

From his kraal in the gross wilderness "behind Chicken
Creek" there came one day to see me one of my very old
Negro friends, Phineas McConner, a backwoodsman of
the finest type. But it was not of deer and wild turkeys and
rattlesnakes that he had this time come to talk. His nine
grandchildren, who live with him, could find no way to
get to school, and he came to see what I could do about it.
Phineas is very smart, and he knows the value of an education.

It seems that the little country schoolhouse had been

three miles from the home of Phineas. For a year his grand-children had managed to walk that distance. But the public authorities had moved the schoolhouse four miles farther away, and seven miles each way seemed a long hike each day in the winter. Phineas lives so far back of everywhere else that the school bus would not make a special trip into his lonesome wilds. When he appealed to those in local authority they gave him very cold comfort. They told him that he could solve his problem by moving near the schoolhouse, but anyone who knows Phineas knows that such a move would kill him. He is the kind of man who can be at home nowhere but in the wilderness. Sad-eyed and deeply concerned, he came to me about this affair.

I wrote to the office of the State Superintendent of Education. No Reno lawyer, pleading on diaphanous grounds for a rich client's divorce, was more eloquent than I in pleading the cause of Phineas. Six weeks later he came out of his wildwoods to thank me for sending the school bus to carry his nine grandchildren to get an education.

One day a local constable drove up to my house. He was hot and bothered. He had a warrant for the arrest of one Caesar, the charge against him being that "he did willfully burn up all his wife's clothes without due provocation."

The quaint wording of the charge gave me a glimmer of hope, for did it not suggest that there might be a degree of provocation that would justify a man in consigning his wife's wardrobe to the flames?

"This man has been dodging me all day," the constable told me. "Can't you help me catch him?"

As I love Caesar, I temporized.

"When will his hearing be?" I asked.

"Tomorrow morning at ten."

"I have to go away for a couple of days," I said. "If you will have the hearing on Wednesday, three days hence, I will produce the person of Caesar for you."

No sooner had he agreed to this, and driven away, than Caesar emerged to me out of a dense canebrake by the river.

On the day appointed I drove him to the office of the magistrate, who is an old friend of mine. While we were awaiting the arrival of the accusing wife, I persauded the magistrate to sit in my car. The morning was cold and windy.

After we had talked hunting for a while I remarked to him that the wording of the charge left a regular barn-door hole, through which the culprit might escape. He admitted it.

Ten o'clock came. No wife. Ten-twenty.

"George," I said, "it's awfully cold, and your courtroom has no heat in it. Isn't a trial supposed to begin on time?"

"If she isn't here in five minutes," he said, "I'll dismiss the case."

In five minutes he did.

As I was driving Caesar home a free man we passed his wife and all her cohorts, on their way to a trial that would never be held.

"They missed the bus," said Caesar.

For a long time I have been thinking that our great mail-order houses ought to wake up. Something is going on of which they have no idea. I will tell you how I became a

party to this gigantic, amiable and ruinous racket. A Negro gets hold of one of these temptation-crammed mail-order catalogues. He has no money. But he is told that the company will send goods C.O.D. Men and women therefore order, on the counsel and advice of the first Negro who has discovered this bonanza, all kinds of expensive articles, especially clothes. I suppose it does give one a sense of well-being to feel, and to be able to tell his wavering best girl, that he has a new suit coming in the mail from New York or Chicago.

The package arrives—C.O.D., $9.98. What happens then? No Negro of my acquaintance has $9.98. Why, the Negro will bring the post-office slip to me. Will I "lift" the package and let him work out the amount? I tried this for a long time, but word went out that I was a perfect package-lifter, and I became so financially involved that I had to give up the whole business. I still have a lot of money due me on packages paid for years ago, but I do not expect to get it back and have as little hope about getting its equivalent in work.

In the South there are in these days conditions that are little understood by people in other parts of our country. For instance, there is a new kind of slavery: every white man in the South is owned by some Negro, and with all our talk of freedom, I do not see here any signs of emancipation. Glance into any rural post office in the South, and see the huge heap of C.O.D. packages for Negroes. Ninety percent of them will either be sent back or will be "lifted" by white people. This problem I tried to settle in one way but discovered it to be the wrong way.

While I sometimes jest at my Negroes' ways, I understand very well what a missionary to Africa meant when he told me that the fundamental mistake he had made when he went to the Dark Continent to civilize the heathen was in supposing that he was spiritually superior to them. In certain ways, intangible and having to do with the spirit, I know they surpass me. They know less about the world but much more about life than I do. Almost from birth, it seems to me, they accept the universe, and even Hamlet would admire their calm reconcilement to "the slings and arrows of outrageous fortune." If they bring their troubles to me, I often go to them for advice and assistance, and I have always found it tinged with the dim infallible wisdom of the ancient sagacity of humanity as a race. For more than fifty years I have lived with and dealt with plantation Negroes, and when the final reckoning of our relationship shall be made, I expect that the balances will go down on their side, for while they may be a little in my debt materially, I shall always be profoundly in their debt for things of a spiritual nature. I learn from them much about the meaning of grace of heart, about religion, about neighborliness.

Old Sue is the Mater Dolorosa of the plantation. She has raised all the orphans and the illegitimates. To be down and out is to have Sue take you into her home and care for you.

Since her house for many years had really been overworked by her generosity and was caving in, I built for her, in my own yard, a humble but immaculate cottage. She had hardly moved in before she took in with her the most

disreputable Negro woman in that whole country—to nurse her back to health and virtue. But it jarred me.

"Sue," I protested, "how could you take that creature into your new home?"

Looking at me with deep eyes that saw something beyond the range of my vision, she answered gently, "Jesus would."

I remember a rather heart-touching dilemma which was presented to my father by one of his most devoted Negroes, Scipio. It seems better not to give the story as a bare statement of fact but to fill in the background. Especially toward the end of his life, Father, who was always fond of children, used to employ a great many colored children—not so much, I think, because of the undoubted help they were to him, as because he liked to have them around.

One August afternoon when we were standing on the front porch, "Lord bless us, Scipio," Father had suddenly ejaculated to one of his favorite henchmen, "that cloud is coming very close. Call in the children and tell them to come to the front piazza."

" 'E will rain," the gaunt Negro responded with oracular effect. Then, putting his hands to his mouth, he gave a long, melodious whoop in a voice that would have set jaded operagoers tingling. In immediate response to the summons a troop of laughing, frolicking pickaninnies came scampering out of the tobacco field, dark in a corner of the clearing near the pinewood, and followed the Colonel and Scipio up to the Great House.

Merry, roly-poly, happy, scantily clad, they straggled up

the broad cypress steps and gathered in a whispering group at one end of the wide piazza. The effect of the Great House on them was to make them wisely grave and urchinly solemn. They felt themselves in the presence of royalty, and levity on the part of any one of their number was punished by awed rebukes and darkly hinted threats of personal violence. They felt that to take shelter on the porch of the Great House was a privilege and an honor, enhanced tenfold by the fact that their love and reverence for the old Colonel approached genuine worship as much as anything in their lives.

Meanwhile, the Colonel, who had disappeared into the house, returned with a long blue china dish piled high with sweet potatoes, steaming hot. He had had them cooked especially for his little workers, and would have it no other way but that he must bring them out himself, much to the sincere delight of Martha, the cook, but much against her apparent wish, for she followed him to the door, expostulating and insinuating with muttered guttural explosions how much more than worthless and trifling were all little Negroes. The children did not know whether to be more awed by the benign expression of the Colonel's face, or by the impending doom, which had storm signals out on Martha's countenance. They were very shy at first, but when Martha disappeared and when the comprehending old Colonel left them to themselves, they very soon did what nature intended should be done when pickaninnies and sweet potatoes meet.

The day had been a typical one for August in the Santee country. A cloudless morning had been followed by a suffocating noon, and that in turn by a succession of thunder-

storms, which left the earth and the air drenched with fragrance and refreshment. After the last rain there would succeed a cool and perfect late afternoon, and for the coming of just such a change Father, Scipio and the children waited on the piazza of the house that stood in patient majesty under the downpour.

The Great House stood in a semicircle of live oaks, gigantic, moss-draped and dreamy with ancient age, and seeming like Dante, their type in human form, to see the world and all its work "under the aspect of eternity." Behind the house flowed the wide yellow Santee through the mighty rice-field delta; before, the fields of cotton, corn and tobacco stretched away to the pinewoods, whose pale purple crests were now misty in the rain.

But thunderstorms in August do not last long, and soon the clouds began to break and the rain slacked. The breast of the seagoing storm could be seen, a gray banner, waving between the earth and sky, passing over the far rice fields beyond the river.

Then the sun came out in a sudden blaze, and the long cotton rows in front of the house steamed in the heat. A cool wind, delicious and fragrant, came out of the great pine forest, and stirred the dark rich foliage of the tall corn dreamfully. Now the drizzle ceased abruptly, and the pickaninnies, who sat quietly enough during the storm, began to grow restless. They talked in whispers and leaned out thrillingly far over the edge of the piazza to look up prophetically at the sweet blue of the pale clearing sky; they chased each other with subdued delight in limited circles; they rolled and tumbled in the rough sandy holes where the concrete floor had disintegrated.

"Boys," called the Colonel, with little regard for particulars, as most of them happened to be girls, "no more work today. Come up soon in the cool of the mornin' and finish clearin' out that corner. It's time to start home now."

The little Negroes who had, each one, stopped violently from their play, as if shocked or frozen, at the sound of Father's voice, now began to file slowly, and with much dignity out of the piazza. "T'ank you, Massa," said each, curtsying as he passed the Colonel. When their bare feet touched the ground they seemed once more charged with their natural freedom and happiness. They sang and shouted and danced down the wide sandy road, happy in the thought of the day's work finished, happy in the thought of going home and of tomorrow's toil, or perchance just happy without thought as children can sometimes be.

The Colonel and Scipio watched them disappear, some through the old gray gate leading into the pinewoods, some into the tall corn fragrant above them, some across a field overgrown with broom grass and scrub pines, beyond which lay the road to the next plantation.

The sun began to touch the pine tops, and its long level rays swept for miles over the mysterious landscape, over the gray oaks, the deep corn, the great dim cypress swamp beyond the river and over the misty rice fields. The spirit of the South drew near with its hushed and holy presence. It is the spirit that makes it a land distinct, inimitable, alone. And the wonder of that spirit has its no less wonderful sources. There are the sweeping lines of her coast with their gaunt austerities; there is the magic of her radiance and her youth, and the pageant of her bloom; there is

the crimson and scarlet of her swamps, broken in exquisite harmony by soft green savannas; there is the majesty of her lordly pinewoods, whose music is the song of the heart; and there is the spell of her loneliness and her autumn. There are her mighty rivers that flow in exuberant peace to the warm ocean, passing in their sweeping pathway to the coast, faint indolent valleys, plantation and cabin, and wide rice field, with here and there a solitary pine or cypress standing like a spectral sentinel alone. But beyond all the pomp and circumstance of nature which make her the rich, the alluring, the picturesque, the lonely South, there are the true and loyal hearts beating there which make her the forgiving and generous South, the South chivalrous, the South impatient of wrong, of injustice, of ingratitude, the South deeply read and long-practiced in the oracles of personal honor and integrity.

The spirit of such a land and of such a heritage had fallen upon the Colonel and Scipio, and the lure and wonder of that spirit made them silent for a time. The Colonel sat on the edge of a huge block of cypress, cut from a single tree, and used as a piazza table. Scipio sat at his feet, leaning against the base of one of the porch pillars.

"Scipio," mused the Colonel, "the old days, the old days! Those little children bring them back!"

" 'E is dat, Mas' Henry," answered the Negro with genuine reminiscence in his voice.

"Can you remember when you played like those little fellows, Scipio?" asked the Colonel, as if in a dream.

Reference to Scipio's irresponsible and relatively unimportant youth never failed to embarrass him, so he merely grinned for reply. He remembered too well those years.

When he had been the age of pickaninnies, the Colonel had brought home his bride. He remembered how all the little Negroes from the quarters had come up to see their new mistress and bring her presents. Wash Green, with a lack of delicacy, which was characteristic of him, even at that period, brought a live rooster with frizzled feathers and, being urged on by Scipio and some other mischief-makers, presented his gift at the breakfast table. The Colonel's bride took it quietly and graciously, though it was the first live chicken that she had ever touched. Scipio brought two hen eggs, saved for a dubious length of time, and wrapped with tender care in Spanish moss. The wonderful and beautiful lady in the marvelous blue dress took them from him with her own hands and thanked him in a way that made him want to do something for her above the mere sordid giving of hen eggs, something like rescuing her from sudden death or taking his own life. The Colonel's exquisite bride had thanked him so gently and so kindly that Scipio, into whose life at home little tenderness had come, became her slave in a finer sense than his father had ever been, and was a devoted and constant worshiper. Ah, yes, Scipio remembered all these things and he guessed the Colonel's thoughts.

"Lord, Lord," ejaculated his master softly, "how it all comes back! You remember Sue and Pino and Mom Rose?"

"I 'member," answered Scipio, knowing what thought was uppermost in Father's mind, but also knowing that it would not be spoken. For, since the death of his wife, the Colonel never spoke to anyone of Blue Eyes.

It was of him that he and Scipio were thinking, falling

silent for a while, of the one who had been the joy of the great plantation, of the little son who had been born to the Colonel and his bride, of the little blue-eyed boy who had been given them. The memory of Blue Eyes, as they all tenderly called him, was the purest thought that Scipio's heart ever knew. Liar though the Negro was, poacher, and one who took many a step that no law could sanction, yet he seemed to hold apart and undefiled and guarded the remembrance of that blue-eyed baby.

When he was born all Negroes on the plantation came up to the Great House to get a sight of their future master. The numberless eager faces radiated only love and good will for the son and heir. And if all their wishes could have been known, they would have proved to be as generous as those of good fairies. The coming of his son affected the Colonel in various ways. He gave the Negroes everything that he could lay his hands on. He could not sit still three minutes. With blithely unconscious monotony he kept humming the chorus of "The Bonnie Blue Flag." When the old reprobate London Legare, who had been given until sundown to leave the plantation, came sorrowfully up, "fo' see my young boss 'fo I mus' leabe," the Colonel nearly broke down, gave London a stiff drink, talked of the more honorable days, told him to stay on the place as long as he lived, and, before he left, presented him with a plug of tobacco, an old pair of shoes and a black coat for Sunday use, never remembering, of course, that London had not seen the interior of a meeting house for twenty years. After that performance, the Colonel went to the tall black sideboard and refreshed himself with what he called "a mild interjection."

As the little boy grew day by day, his features becoming like those of his father, though he had his mother's great wondering eyes, he was assumed to be the personal property of the whole plantation, and from the Great House to the quarters, from the river to the pines, he was known and loved as Blue Eyes. His hair was wavy and bright, and his body was sturdy and strong and sweet in childish symmetry. The beauty and promise of his growth was coming to pass like a thing prophesied and prayed for. Blue Eyes was everyone's care and delight, but of all the Negroes Scipio was the most devoted.

Scipio had not been born a "house Negro," one with domestic instincts. The role of a butler would have bored him. An apron and a countenance controlled would have fitted him ill. He was of the fields, the river and the woods. He was too big and too natural for the trying parts that a house servant must needs sometimes assume. This very love of the open and the free was what gave Scipio the greatest privilege and honor of his life. For when Blue Eyes was out with the nurse Scipio went with them everywhere. Now they would go down to the barnyard to see the hands threshing rice with their quaint flails in the warm winter sunshine; now they would go just near enough to the river to catch a glimpse of its sluggish waters —for the Colonel had set a dead line, beyond which they might not pass; or again, Blue Eyes would say, "Wide, wide!" and the ever-delighted Scipio would take him on his back and ride him down to the edge of the great pine-woods, dewy and silent and deep in the purple shadows. And so two happy, happy years passed. Then there came a day when the little boy fell sick, and the old country

doctor who was called looked grave, and when the heart-broken Colonel whispered to him, he shook his head in doubt.

When the Negroes heard that Blue Eyes was sick, they went about with troubled faces. They tiptoed over their cabin floors. They cuffed their own offspring with sudden and unaccountable violence. Often they would pause at their work in the fields to gaze up at the sky, as if expectant of some starry Deliverer. They prayed the great simple prayers of a primitive people. Day after day the pathos of a long line of powerful men, sorrowing women and awed boys and girls came up to the Great House to ask after their Blue Eyes. And all day and all night the dusky boy Scipio sat on the carpet outside a certain hushed door and sobbed for his little treasure and companion. Then came the "sleep and the forgetting," and the wide glory of a little boy's innocent blue eyes was no more seen. The rich plantation was left solitary, and the mourners mourned many, many days.

It was a memory of those days that held the Colonel and Scipio so long silent on the piazza, while the twilight fell and the night mist began to rise.

"Lord bless us!" ejaculated the Colonel presently, with admirable mastery. "It's late—late. I must be going. Get that horse in for me, Scipio—no, saddle him. I'm going to ride down to the village tonight."

With that he disappeared into the darker shadow that marked the opening of the front door.

Scipio brushed his sleeve roughly over his eyes. Then he lifted himself on his gaunt arms and ambled off quickly after the horse, for Father was ten miles from his summer

home on the coast, and it was dangerous to be caught in the malarial district along the river after night.

The old Colonel felt his way through the lonely rooms of the twilight-darkened house until he came to his own. The hot tears that he could not bear Scipio to see now streamed down his face. Blinded by them, he still felt his way along the mantelpiece until his hand fell on a miniature. He lifted it tenderly from its place, sank to the floor against a great armchair, and buried his face in his arms.

The tall room was shadowy with silence. There were none of the mysterious sounds that could come with the later darkness. There was but the intense stillness of the aftertwilight, broken now by the sobs of a brave true man who was longing for the music of a little voice, the smile of a little face, the touch of a little hand.

But the father's agony was brief, for he heard Scipio returning. Rising, he pressed his lips to the miniature, slipped it back in its place on the mantel, passed to the washstand, where he bathed his face, and so went forth into the piazza refreshed and controlled.

Scipio walked down as far as the pine-wood gate with the Colonel. Later he would return, lock the Great House, and then go across the rice field to his own cabin. As they reached the gate and the deeper night cast by the woods they paused, and in that interval there came to them, sweet and clear from some far plantation, the voices of Negroes singing. The chorus swelled melodiously over the pines.

> "I will meet you,
> Yes, I'll meet you;
> O, I'll meet you in de Promise' Lan'."

The music, and the memory and the tender darkness loosed the tongue of Scipio so that he asked a question that had haunted him for forty years.

"Mas' Henry," he said softly, "I know fo' sho' dat you will see Blue Eyes sometime, you an' de missis, but how 'bout me? How 'bout Scipio? You t'ink de good Lord will lemme see him jes' once mo'?"

Again the Colonel felt his tears. Reaching down in the darkness he caught Scipio's hand.

"Yes, Scipio," he said with gentle assurance, "you will see him again, and be with us in the Promised Land."

Then he rode away into the night.

As Scipio walked slowly homeward he looked from time to time at the stars, at the solemn river, at the watchful oaks and the mourning cypresses, and a great peace was in his heart.

"Yes, my Lord," he murmured, "in de Promise' Lan', in de Promise' Lan'."

Chapter 4

Dark Valor

ABOUT the things that fundamentally concern the human spirit, women are nearly always right. If a man does not happen to be made like a Hercules or an Apollo Belvedere, he is sometimes wont to complain because women instinctively admire and prefer soldiers, athletes, rugged two-fisted individuals. The truth is that what women most love in a man is courage, and all that courage suggests to the imagination. Physical triumph carries with it the implication of valor; and, behind the valor, security. Women glory in the dauntless, and in this they are right, although sometimes they are not quick to discriminate between the pseudo and the genuine. However, in their defense let it be said that when they do discover the spurious, they generally despise it.

Mankind somehow has come to associate valor with the deeds of the great. "Names make news," is the slogan of every newspaper. But no class has an option on courage. I have known some soldiers to be arrant cowards, some famous athletes who were yellow, some heroic-looking men who had shoestrings for backbones. And I have known people utterly obscure and humble who have done things so gallant that, were they in the public eye, their acclaim would be national. The more we consider the universal possibility of valor, the more we come to feel that the only common people are people with common souls, and by

"common" I mean, in some sense, cowardly. At any instant, out of any rank, the hero suddenly arises. All people are possible heroes and heroines, and they are as likely to come from cabins as from palaces.

Some of the very bravest things that human beings have done have been the achievements of the meek and the obscure, people so humble indeed that they had no conception whatsoever, no consciousness, of their own gallantry.

Perhaps a few stories out of my own experience will serve to illustrate the principle that the dauntless heart may be found in the frail body, and with a background unknown to fame. We shall find that sometimes a man weary, weaponless, alone, will keep his heart's high citadel against disappointment; his foes, discovering him, shall not discover fear. He will even challenge fate with a "Halt! Who comes here?" I say such a man is a victor, even though he may perish; that even death takes no trophy from him to hang in his dim memorial halls; that the citadel stands as before, with all its banners streaming from its battlements.

No human being, by birth or heritage or environment, has the gateway of heroism closed to him. And every man and every woman has the opportunity to be thrillingly courageous. Life calls for no quality more insistently than for simple bravery. Perhaps only the soul has the power of deathless security. I have discovered it among some of my Unknown Soldiers whose valor has inspired me.

As they reaped rhythmically, the Negroes in the golden wide rice field were singing melodiously. Their steady ad-

vance bowed before it the tall ripe grain. Mellow sunshine steeped the scene, and there was the glamour of autumn and of harvesttime in the air. It was cool for September in South Carolina, and there were hints of fall in the air, although that radiant, reddening, ripening time had as yet been stayed from the heavy-foliaged trees that fringed the great rice field. Toward the owner of the field, who had been watching the Negroes with delight, there now advanced down the long bank the smiling Mobile, grandson of the old professional Negro hunter of the plantation, who, much to the pride of this unique personage, was always addressed as "Hunterman."

Mobile well deserved the title, and his adventures in the abysmal Santee Swamp and in the wilds of the gross Santee Delta were an epic in themselves. No Cherokee or Seminole who ever ranged the pine forests or the cypress swamps of the South had understood them better than he. He possessed a certain untamed element in his nature which served to ally him to all wild things and their ways. His occupation was never fixed, unless roaming in search of game can be considered an occupation. Real work he disdained. But Mobile was full of picturesque accomplishments. He could pick the guitar and roll out his velvet bass in spirituals; he could arbitrate differences among the Negroes; he could prescribe medicines for them in case of sickness; and these remedies, being gathered from plantation woods and fields, were often beneficial, and always they were "without money and without price." But by birth and breeding Mobile was a hunter. It was he alone who could, after nightfall, take the direct road home out of the most desolate swamp. He alone knew where the

wariest old buck would lie, and at just what point in the vast level pinewoods a running deer could be cut off. In all such matters, the planter had come to defer to Mobile, but he had to confess to himself that Mobile was hardly an economic asset. He didn't hate work, for he never hated anything, but he just had a total disregard for it. But Mobile made up for his laziness by having about him a certain wild and woodsy air of romance, and he was as fine and picturesque a figure of the black man as the Santee country had ever produced.

Tall and spare, he had the power of endurance written in the movements of his limbs and in his easy attitudes in repose. All his actions appeared to be without effort, for he did things without appearing to strive. A great Olympic champion was probably lost in Mobile. In his features, he was more like an Indian than a Negro. His eyes were deep-set and keen, with a masked glitter of forest wildness in them. The expression of his face was quiet yet indescribably wary, while the gleam of his ready smile almost constantly lighted his cheerful countenance. Primitive, powerful, a child of nature, Mobile was an easy man for the whites to love, and to the Negroes he was almost a god. Had he not killed the great octopus on the wreck at the mouth of the river? Had he not slain with his own hands the monstrous alligator of Dead Indian Lagoon? Had he not proved, time and again, that he was without the thing called fear?

Now, as Mobile approached, the planter who stood under a gnarled live oak on the rice-field bank, eyed the Negro's musket with mock disapproval.

"Well, Hunterman," he said, "and what are you loaded for this summer day?"

"Boss," the Negro answered, "I come from Laurel Hill Swamp. Two big bear done take up there, but I couldn't come up on dem today. But I'se ready for dem. I has a ball bullet in my musket, sah," he ended, stroking trustfully the long barrel of his formidable weapon.

The eye of the planter rested with amusement yet with admiration on Mobile's gun. Of an age unknown and of a fashion long forgotten, short and heavy in the stock but marvelously long in the barrel, it was throughout so pitted with rust spots and powder scorches that frequently, when fired, it emitted at various corroded seams and joints, spurts of angry flame. The misshapen hammer looked ancestral, almost prehistoric, while the nipple was nothing but a worn stub. But in the hands of the redoubtable Hunterman, and charged with the double load that he was accustomed to using, it was a deadly weapon. The sound it made was unlike that produced by any other kind of gun. Mobile's musket blared and did so alarmingly. This fearsome roar was known to all dwellers in the Santee country, and its significance filled everyone who heard it with deep pride in Mobile's daring and prowess. On stormy twilights, when the wild ducks would be pouring into the old rice fields, a fearsome sound like the crack of doom would crash upon the stillness of the plantation regions and would reverberate for miles up and down the misty reaches of the river. Then the Negroes, hugging their cabin fires, would say: "Huh! Dat's Mobile. What chanst is dem duck got 'gainst Mobile?" Again, when the roar of the musket would come from the pinelands, there would always be

some Negroes who would hear it and would remark, "I'se gwine put on my pot, 'cause I know Mobile will give me a piece of that venison."

So now, when Mobile laid his extraordinary weapon down on the dewberry vines that had matted themselves on the slope of the rice-field bank, the white man eyed it with affectionate fun.

"Time you were getting a new gun, Hunterman," he said, "someday she is going to blow up and scatter you far and wide."

But admiration for Mobile's skill as a woodsman now suffered a certain eclipse, as, looking across the stiff brown rice stubble, he saw the Hunterman's wife toiling faithfully with the men and with the stronger women, though her youngest child was but a few weeks old. Yet it was hard to get angry with the picturesque Mobile; one might blame a domestic nature for such neglect, but not a nature essentially wild, primitive, restless. Yet the planter could not forbear saying: "Mobile, you know this is no season for you to hunt bear. Why aren't you in that field reaping rice? You know that Amy ought not to work as she is working yonder while her baby is so young. Amy ought to be at home with your child, and you ought to be in the field."

But the Hunterman ignored the planter's cogent reasoning.

"I done seen him yonder," he smilingly said, the light of a deep, shy, wild, woodland affection for his only son coming into his eyes. "He done been asleep in the grass by the bank," he added softly, and still smiling, as if he were afraid of waking the child, and as if the performance of sleeping by a baby were both wonderful and amusing.

To the disagreeable subject of work no further reference was made, for Mobile, taking advantage of the change of subject, straightway began to tell the planter of a family of black fox squirrels near the northern bound of the plantation that had been marked for the winter pastime of the planter. The talk continued to be of things woodland until Alston moved out from under the dense little oak, thinking that he would walk a little way down the bank to see what progress the harvesting would show from a different angle. Like every planter the world over, when he had emerged from the shelter which had cut off his view of the sky, with its ancient tokens of fair or stormy weather, he glanced upward. Mobile, equally solicitous about such matters but from far different reasons, also looked up. Both men saw at a glance the same dread apparition.

On swarthy and powerful wings outspread in the heavens, in one of those last lowering circles ere he should fall upon his prey, a great bald eagle was wheeling. Unconscious of the presence of the two men standing beneath the oak, he had been circling above them, they knew not for how long. The reapers in the field were now too far away to disturb him. And the moment that the watchers on the bank discerned him, certain at last of his recognizance and of the exact position of his prey, the dark marauder eagerly arched his mighty wings, and volplaned roaring out of the sky. His snowy head, with its cruel beak partly open in the heat of the hunt, was slightly outstretched. His stocky legs were letting down their grim talons to grip their prey. The fall of the eagle was terrible, a fearfully beautifully impressive spectacle, yet most sinister in its primeval splendor.

The planter cried, "What an eagle, Mobile!"

But the dusky Hunterman, like lightning to think when wild life was in sight, had instantly discerned the goal of the great harrier's fall. In an instant he had marked the tragedy.

"My little baby," he cried brokenly, "dat big eagle's gwine to get him!"

The Negroes in the rice field, who were working at some distance from the bank, were totally unaware of the impending disaster. Laughing and singing, they were reaping happily. Even if they had seen and had realized what was taking place, they were far too distant to help. The eagle might have heard their shouts, but he would not have released his pitiful prey. Always bold, the bald eagle is amazingly so when a coveted victim, almost within his dread clutches, seems about to be taken from him. In the golden field the little child's mother was singing with the rest, swinging the flashing sickle rhythmically and laying the heavy lustrous sheaves in windrows on the brown stubble.

At first only the two men on the bank were aware of the terrible scene now being enacted before their very eyes. If the child was to be saved, they alone must do it. Yet what hope had they of succeeding?

The plumed coffee grass beside which Amy had laid her child was more than a hundred yards from them down the grass-grown, brier-matted bank. It would take the men at least fifteen seconds to reach the place, and by then the black miscreant, bearing his precious prey, might be far beyond the cypresses on the riverbank, or even beating

his powerful way over the broad reaches of the river itself. It was a desperate moment.

From a great height in the sky the eagle had detected a movement of life in the grass on the bank, and the colorless cloth in which the baby was wrapped had given him no reasons for suspicion. He saw some kind of prey beneath him, far from the workers in the wide field. He might have taken it for a rabbit or a tiny fawn. At any rate, he marked it for his own.

Lower he wheeled, and more swiftly, deftly calculating the distance and gazing down balefully at his victim with the piercing sight of fierce clairvoyant eyes. The little creature that he probably imagined the young of some animal was, he saw, alive and defenseless; therefore he would fall upon it. With his curved talons wide, like a black thunderbolt he dropped out of the blue sky, the wind roaring through the hollow arches of his wings. His talons ached for the fatal grip. His steady eyes were aflame with cruel hunger, and with the anticipation of its instant satisfaction.

The moment that the planter realized the terrible import of Mobile's words, he sprang forward with a shout, and would have raced down the bank, almost beside himself as he was with the pity and horror of the thing. But the Hunterman, gripping his arm, stayed him.

"If you shout, Cap'n," Mobile cried, "he will fly faster. We couldn't get to him now nohow. But wait a minute, please, sah. I see one chance."

The huge eagle, whose fall had been completed, and which for a moment had been buried in the thick grass, now rose heavily above the bank. Gripped in his talons and held close to his tawny body was Mobile's baby.

But the Hunterman was going to have something to say in the matter. He was kneeling on the bank, his old musket on his shoulder.

"Mobile," cried the planter poignantly, "what are you trying to do?"

"I'se gwine to shoot him," the Negro returned, in tones that betrayed not a tremor.

The planter stifled a wild desire to protest against what he felt sure would be a peril as grave to the child as the eagle's attack. But instinct and a trust in Mobile told him that it would be better not to speak. The Hunterman was taking aim. The shot would be the most difficult and dangerous of his whole life. It was a moving target, swiftly gathering momentum, and held close to the target was a precious human life. Then, the plantation owner remembered that Mobile had told him that his musket was loaded that day with a single ball—a "ball bullet" he called it, meant for bear in the great Laurel Hill Swamp.

In the fleeting second while the planter crouched breathless beside the kneeling Negro, he caught the expression on Mobile's face. It was tense but not nervous, and flintlike in its determination. Steadily the eyes gleamed. There was not a quiver in the statuesque black figure, immovable as marble.

The workers in the rice field had heard the planter's first shout, and the nature of the tragedy was borne in on them by one of their number who, being a hunter, cried out the danger. The black marauder caught their gaze at once. Now they could see the tiny child, wrapped in the drab cloth, struggle feebly. They could not hear the pitiful little wail that came to the ears of Mobile. Amy, the mother,

had begun to run wildly across the stubble, waving her arms, shouting and weeping. But the great eagle had nothing to fear from those far-off pursuers.

Ponderously he rose, gaining assurance as he gained some altitude. But because of the weight of his burden, he could not rise high. His mien was kingly yet scornful. He was accustomed to triumph. But then on the still air the old musket of Mobile blared. And the giant marauding bird, collapsing in his skyward flight, fell heavily in the dense marsh on the edge of the field. The aim of Hunterman, even in such a crisis, had been true, and the single ball bullet of the Hunterman had gone home. The baby was recovered unhurt.

In a few minutes Amy had her child in her arms. And then something happened that pleased her as much as the miraculous shot that Mobile had just made.

"Give me yo' sickle, Amy," Mobile said, "as long as we'se got a lil' baby, I will never let you work no mo'."

That great eagle, the largest ever taken in the Santee country, now mounted, is one of the planter's treasured trophies. Though he can never look at it without something akin to a shudder, yet always it vividly recalls one of the most thrilling moments of his life, when an innocent child was saved from a terrible death. When he and Mobile look at the eagle together, they understand each other with a perfect affection. And the planter will say, "Mobile, to this day, I don't see how you did it."

Mobile will answer, "How, Boss, ain't I yo' Hunterman?"

As Father had been a soldier, there was nothing he ad-

mired more than valor, and he loved to quote Johnson's, "Courage is the first virtue in a man as chastity is in a woman." He treasured especially what might be called un-expected heroism, particularly in humble people. He taught me that while Parnassus is Parnassus, there are little hills that look as surely heavenward. The humblest heart has equal access to God, equal possibilities for heroism, mental or physical, with the most splendid. This is what makes the only true democracy. Though no one else on earth may ever know of it, it is conceivable that each one of us might achieve imperishable renown—a glory of spirit that redeems humanity.

I recall his telling me with almost a faltering voice of the dauntlessness of Ben, one of his Negro friends.

For half a mile on either side of the narrow bank, over-hung by lush grasses, the wide rice field was deep under water, only the golden heads of the plants showing above the quiet tide. From the mainland to the river this bank stretched across the field for a distance of seven hundred yards. Down it one September twilight, Ben and his brother William, plantation Negroes, shambled with their easy gait. They were going down to their boat, moored on the river, for a night's fishing.

Reaching the riverbank in the dusk, while Ben began fumbling with the rope that tied the boat, William sat down, trembling all over.

"Brother Ben," he said very soberly, "it may be that a briar scratched me when we done come down the bank, but I feel very sick, and my right leg is swelling up and is paining me."

It was then that Ben remembered, that somewhere back

on the dusky borders of the bank, in the misty shadows of the saw grass, he had heard a muted but sinister whirring; he remembered also the evil rumor which had been current on the plantation for a week: that a huge diamondback rattler had been haunting the riverbanks and the check bank across the field. Such a reptile, leaving his lair in the lonely pinelands, comes to the rice fields after wood rats, which, in turn, come there after the ripening rice.

Almost as soon as William had made his complaint, he sank back in the grass, murmuring in agony, "I wish I was home."

The nearest help across the river, or up or down it, lay many miles away. So dense was the stand of rice in the great field that to try to reach home by dragging the waterlogged boat over the bank, and paddling it through the growing grain would have meant fatal delay. Ben knew this, as he knew that there was but one thing to be done: he must carry his brother home down the same death-beleaguered bank over which they had come, and he must do it at once.

Neither man had on shoes or socks, and from the knees down their trouser legs were practically gone—frayed to mere occasional wisps of cloth, offering no protection. Twilight had come, the very hour when venomous serpents are most active and vicious. They are beginning a night's stalk, and they resent interference. To carry out his plan, Ben simply had to walk by sudden death—with an excellent chance of rousing the ire of this ambushed terror. To walk up to a diamondback in the dark calls for a very special kind of nerve.

Well, all I know is that Ben did carry his brother safely across that dreadful bank, getting him home in time to

save his life. Ben never liked to talk of that experience, and his part in it failed to impress him. But one day, after my persistent questioning, he said, with unconscious and therefore superb effect, "I carried William high on my shoulder so that the snake wouldn't strike *him* again."

This is the sort of valor that I have known Negroes to display, and that is why it makes me very impatient to see them represented on stage and screen as fearful, cringing mountebanks, as terror-stricken minstrels, having no characteristics so salient as arrant cowardice. I have known brave Negroes, and their courage is genuinely impressive because it never is what so much modern so-called heroism is—a publicity stunt, calculated to win money or applause.

A thing happened years ago on a plantation near ours that should bear out the truth of what I believe about the Negro's courage. It was another exploit of a man I have already mentioned.

A man of the woods and the lonely waters, of the deep cypress swamp and the solitary pinelands, Mobile, the giant Negro trapper, was usually ready for whatever unexpected crisis came. The kind of life that he lived always teaches a man the invaluable lesson of being resourceful. But he certainly was not prepared for this dramatic and really terrible occurrence, the awfulness of which was heightened by the fact that it happened right in the plantation yard, and almost under the eyes of a score of Negroes joyously threshing rice. They had been singing as they wielded their huge hickory flails, beating the grain from the long golden straw.

Mobile had not been threshing; he had been regaling the crowd with stories of woods and waters, which the workers, in the frequent pauses in their work, found ample time to listen to, to laugh over and to wonder at. Despite the fact that Mobile was a far more active man in the wilds than in civilized surroundings, the plantation owner liked to have him about. He always had a fund of stories to tell about his varied adventures, and he kept the toilers in high good humor.

Suddenly, in the midst of a yarn about an alligator that had upset his dugout cypress canoe—a tale in which his listeners were enthralled, and which produced an unusual silence—on the still and balmy air there broke a wild cry, a shrill shriek of terror and despair. The Negroes were for a second stricken dumb; but the nature of the cry was too unmistakable. They knew that something dreadful must have happened. Naturally they looked toward the tall roof of the great plantation house, fearing fire, for fire is probably the greatest dread of those who live in that region of stately colonial homes. But they saw no smoke or flames. Then, as if by a common impulse they began to run toward the place whence the distressing cries continued to come. Someone in the front yard was shrilling wildly; more than a score of figures came darting from the house and from the threshing yard. Of all these, Mobile was the first to reach the Negro woman who was wailing brokenheartedly.

To his amazement, Mobile saw that near the woman was standing an Italian of very gypsylike aspect; and at first the trapper thought that the woman had merely been frightened by the bearded and uncouth foreigner. But there was trouble of a worse—of a dire sort. Both the

woman and the stranger were pointing excitedly toward
the roof of the house, and now all eyes gazed upward, to
be horrified by the sight they beheld.

Chattering obscenely, a loose chain dangling from his
collar, a huge ape was pulling himself over the eaves of the
front porch, and even as the terrified crowd gazed, gained
the roof itself. From it came a sound other than the beast's
own chattering, for, gripped under its left arm it held the
little child the Negro woman had been watching. The
nurse and child had been in front of the house, the little
girl playing in the white sand there; the wandering Italian
with his monkey (a huge one, and dangerous) had ap-
proached with his hurdy-gurdy. He had asked civilly
enough if he might play and make the ape perform. The
woman, simplehearted and bewildered, had talked with
him for a moment. It was a fatal moment, for in it the ape
had wrenched himself loose from his master's hold, had,
in a fit of perverseness and pure deviltry coupled with a
wild longing for freedom, seized the child, awkwardly but
swiftly rushed toward the house and with wary nimbleness
climbed the fluted pilaster against the house—a big ivy vine
giving him all the support he needed. Now he was on the
porch roof, and he was going higher. While the awe-struck
throng gazed, the ungainly creature ascended the next
slope of the roof, and in a few moments had gained the
very rooftree itself, upon which he calmly sat, gazing with
a triumphant leer at the petrified and helpless people be-
low. His hold on the child was somewhat relaxed—he re-
tained it rather negligently, as if half-forgetting the bur-
den.

The ape and the child were at a dizzy height. From the

rooftree to the ground was not less than eighty feet. The roof was steep and smooth; the cypress shingles had been weathered until they were glossy where the heartwood stood away from the weathered sapwood. A false step on such a roof, a single slip—and there was nothing to save one from the dreadful plunge earthward. Yet on such a place this wild creature dangled carelessly the little girl who was the idol of the whole plantation. Her baby voice, her auburn ringlets, her tiny chubby hands, her innocent loving heart—all these the plantation Negroes knew and loved.

Nor, among all those gazers, was there a single white face save the Italian's. The family that owned the great white house had gone away for the day.

The distracted nurse kept weeping to the Italian, "Get him to come down! Get him to come down!"

"I can no get!" he protested with painful earnestness. "I can no climb! Da monk is rascal of a monk! I can no get! You, Bep," he yelled shrilly to the ape, "come-a to me!"

It was evident the ape heard; and it was likewise evident that he sardonically enjoyed the consternation he was creating. He stood on the rooftree, capered down its length bickeringly, bowed at the terrified crowd, and deliberately shook the child at them. Then he sat down on the smooth roof and deliberately began to slide toward the beetling eaves. Suddenly a huge hairy arm shot backward, and he caught the top of the roof, then pulled himself lithely up again.

The effect of this scene on the crowd was varied. Many of the women set up a mournful wailing, as if all were already lost. Some of the men looked threateningly at the

Italian; others, coming to their senses after the first terrible shock, began to shout that ladders should be brought. In response to this call, at least a dozen men and women ran toward the back of the house, immensely relieved to have something to do. But, since he had first arrived on the scene, Mobile had not moved, nor had he said a word.

His eagle eyes had been fixed on the ape. He had also measured the height and the slope of the roof and had studied the senseless and malicious wild thing poised there aloft. . . . It was he who now drew the excited Italian aside, his huge hand and the gentle but powerful pressure thereof quieting that jumpy individual.

"Will the monkey come down for you?" asked Mobile.

The mountebank declared volubly that he feared he would not.

"Can you climb and get him?" asked Mobile.

The Italian declared that he had never climbed in his life. "But you," he added shrewdly—"you know that roof vera well. You could climb heem."

"I got my musket," said Mobile. "I can kill the monkey with one ball bullet, and never touch the baby. . . . But it would fall; they both would come down together."

The Italian suddenly remembered something. He reached in his pocket and pulled out a banana. This he held up enticingly, calling the while to the ape, which seemed to understand at once the purpose of his master. But the monkey had no intention of being lured down.

"I will go up and get him," said Mobile, seeing that the creature was unaffected by his owner's pleading.

"You fall," the Italian protested in warning. "Da monk, he throw you off."

"If I come, he will come with me," the Negro answered simply.

The ladders had by this time been brought, but it was noticeable that climbers of them appeared singularly lacking. No woman volunteered, and every man had some excuse. They were not, indeed, afraid of the ladders, the slippery roof, or the dizzy height. But they had an innate dread of the ape. His rarity, his seeming human intelligence, his grotesque aspect, his eerie deftness in climbing and in balancing himself—all these filled the Negroes with a superstitious dread. Mobile suddenly disappeared from the excited and waiting throng. When he returned, under his arm was lightly slung his musket. He walked up to the Italian.

"I done already has changed my mind," the huge Negro said amiably. "I want you to climb up. The monkey might come to you more gentlelike. We must have the child safely. . . ."

"But I tell you I no can climb!" the Italian protested.

Mobile's musket slid down negligently until he gripped it in his right hand. Into the calm eyes of Mobile there came a glint, the threatening import of which was unmistakable.

"You can climb," he said with utter finality, "if I say, 'climb!'"

The Italian heard the commanding tone; he saw the hand that gripped the gun—he suddenly decided that he could climb, after all.

"Now, don't you forget," warned Mobile, "that what we want is that little child—safe and sound. I mean business when I say you must climb," he added.

Toward the huge ivy vine the Italian went, furtively, but apparently with good intent. He made it understood that he preferred to clamber as the ape had done, up the vine and thence to the lower roof, than go up one of the swaying ladders.

But Mobile's plan for a rescue of the child was not destined to be fulfilled. No sooner had the Italian gained the roof of the porch, some thirty feet below the rooftree on which the monkey was sitting, than the ape began an angry chattering—a threatening jabber that seemed to show that, in captivity, the beast might at some time have been master as well as servant. Then ensued a cruel and fiendish device on the part of the ape to keep the man away from him.

The creature evidently realized he had done wrong, and any animal with guilt in its heart is likely to be treacherous. The ape moreover knew that he had done two wicked things—to escape and to snatch up the child. His master was now coming to capture him, to beat him for what he had done. Even a more brutish mind than his could understand that much. The ape not only realized what it was that he had done, but he conceived an ingenious method of avoiding capture and punishment.

As soon as his master appeared on the roof below him, he held the child out far from him, as if to drop it. The Italian took a step upward toward the second roof. The ape actually laid the child on the sloping roof, pushed it downward with his foot, and then pinned it with a single great hairy toe. These maneuvers chilled the blood of the onlookers. The beast's master appeared to know that the game was against him, for he turned to look down helplessly at Mobile. Mobile, his keen eyes appraising the situ-

ation, saw the menace, and quietly called the man down. He himself ran toward the outhouse where various tools and other things of the plantation's equipment were kept, and by the time the trembling Italian was on the ground, he was at the foot of one of the ladders. He had in his hand a hammer and a castnet—such a net as is used along the southern coast to cast for mullets and shrimps and other similar kinds of game from the waters.

Ere he mounted the ladder he called the whole crowd to him.

"You people," said Mobile slowly, "listen to me now. If you don't listen to me, you gwine to be sorry before this day is done. I'se gwine up there to get the baby, but if she should fall, you must try to catch her. Go now, run, get three or four of them big rugs out of the house, and six of you hold each one. Keep under the place where you see that monkey. When he moves, you move. Keep opposite him all the time. . . . You understand?"

Up one of the tall rickety ladders went Mobile. Lithely he climbed, fearless and free of limb. Reaching the eaves, he stepped out naturally, as if he were on the ground. He paid not the least attention to the ape. Indeed, he did not give it even a furtive glance. Had he done so, he would have seen that, to the horror of the watchers below, the crafty creature had actually perched itself on top of one of the great chimneys that stood some four feet above the roof line. The child was now closely clasped in its arms.

All eyes turned from the ape to Mobile, but the huge trapper seemed to have gone to the roof to fix the loose shingles. The net he carried was wrapped about his left arm and hand. He managed to make the hammer which

he carried in his right hand very prominent. He felt over the shingles; then he would tap down a started nail. Apparently looking at the roof, he located the ape, and toward him he moved by inches, but so obviously intent on his work that the creature did not recognize in him a pursuer. Mobile began to sing softly, keeping time now and then with the blithe tattoo of his hammer. The ape was at first bewildered, then he became interested, and then curious. Sedulously he slid down from the chimney, and then perched himself astride of the rooftree. Mobile kept on coming inch by inch, and already he was beginning negligently to loosen the net from his left arm.

The ape was fascinated by the work Mobile was apparently doing. Now and then he would edge himself an inch or two nearer the man, so that quietly and unobtrusively they were really approaching each other. Mobile did not go straight up toward the creature, but rather made for a point on the roof line some ten feet behind him. . . . All the while the burly trapper kept a close watch on his friends below. They followed his every movement. Once only did he call to them, and then in a perfectly natural voice, as if he were asking someone to bring him up some more nails. This was when he had nearly reached the apex of the roof.

"See here, Tony," he called, "listen now. When I lift my hand, some of you begin to dance and shout, so that he will look at you."

Mobile at last came to a place whence he could reach up, grasp the edge of the roof line, and pull himself up to the top. In a moment or two he had done this leisurely, tapping meanwhile busily with his hammer. The ape had been

half-turned to watch him, but it had not faced about. Mobile had the net now loosed and held in such a manner that in a moment he could whirl and throw it. He measured the distance, calculated the height of the ape from the roof line, made his knees hug the roof to hold him in place against the shock that he knew was coming. To fight a burly ape eighty feet above the ground, where the footing even at its best is precarious, is no pleasant task. But Mobile was not afraid. He had taken the thought of the child in his heart. Nothing else mattered.

Quietly he held up his hand, as if he were stretching it up to make his sleeve fit comfortably on his arm. Immediately, below a clamor began. Some of the younger Negroes, carefully instructed by Tony, began to sing and dance and shout. . . . Swiftly the ape turned his head and peered down.

Mobile had laid down his hammer. The instant the ape turned his head, the giant trapper whirled the net in a graceful mighty circle, shot it forward and up, and sent it squarely over the crafty creature.

There was a leap, a wild snarling and scuffling. The ape tossed the child from him violently, but it lodged safely against the side of the net. Mobile set himself against the roof to hold the net as it rolled with the heavy weight that it enclosed perilously down the slippery roof. The Negroes below were ready to catch what might fall. But the net held fast, and Mobile held fast.

"You white man," he called, "come up now and get your monkey!"

From the high roof, Mobile let himself be drawn gently by the weight of the sliding net. Soon he was on the lower

and safer roof. By that time he was joined by the Italian and by several of the older Negro men.

The Italian's wild cries at the ape sobered the creature, so that he permitted himself with crafty meekness to be taken by the collar, disentangled from the net and hustled down the ladder by his master.

The little child, unhurt but disheveled and bleeding from scratches and bumps, Mobile lifted in his huge arms and bore safely to the ground. There he laid her tenderly in the arms of the weeping and rejoicing nurse. . . . The Italian and his ape, believing that their presence was probably no longer welcome, made a hasty departure for parts unknown.

Loud were the praises that the plantation Negroes gave Mobile, and deep was the gratitude of the little girl's parents when they heard, with wonder and terror, of their little daughter's desperate adventure. For his part, Mobile thought little of the occurrence, and no sooner was it over than he repaired to the rice yard again and regaled his friends with more of his droll stories of life in the woods of the Santee country as he had lived it.

There are many men more intelligent than Mobile, richer, of a different color, of another creed. But when it comes to quality of heart, you will hardly find his superior.

Chapter 5

God's Children

IN THE stately language of the Prayer Book character is "an outward and visible sign of an inward and spiritual grace." It is only by properly relating these two that we can even arrive at a just estimate of people. I have described the Negro as capable of deep affection, humility, fealty, courage, long and loyal remembrance. These are evidences of inner grace. Always, however, the illustrations of a truth are more appealing and convincing than a mere statement of it. Here are examples of what I mean by the fine spirit of which the Negro is capable. If his nature is perhaps a little short on moral indignation, that, it should be remembered, is a quality which is sometimes used as a shield for much intolerance.

I personally long have known that I had much to learn from the Negro. I have been indebted to him for many secrets of woodcraft; for the fine philosophy of good cheer; for droll stories which are witty without being like Balzac; for a peculiarly effective understanding of animals; for craftsmanship in masonwork, in carpentry, in boatbuilding; for an unwearied spirit in fighting, through the humid summer months on a vast plantation, acre upon acre of waist-high weeds; for the quiet acceptance of many of the changes and chances of life; and for a pure and abiding faith in the goodness of God. I do not mean to say that I have acquired all these virtues, but in the Negro I have

seen them, recognized them, and learned to respect them. I wish that all of them were mine.

I am glad to honor him for the part he has played in the history of our country. He has cut our wood and drawn our water; he has felled our forests and dug our canals. He has plowed our crops, raised our stock, and he alone has had the wisdom to put some sense into the heads of idiotic mules. He has borne the burden and heat of the day. There is hardly a family in the Deep South for whom he has not been a watchman at the couch of birth and at the bed of death. His songs and his sayings have passed into our language and our lives. He has not only toiled for us, but by his music, his mirth, his fealty, and his philosophic acceptance of life and of death, he has spiritually enriched us. All these things represent a vast debt, unpayable, of the white man to the black.

Plantation Negroes still believe profoundly in spirits, good and evil, and in charms; and a little belief in sorcery goes a long way. A doctor has always to contend not alone with a Negro's physical ailment, but to some degree with those obscure taints of the mind which are the infections of superstition.

On one occasion one of my Negro wood choppers cut his foot deeply with an ax. I knew nothing of the accident until three days later, when I found the invalid sitting in the sun beside his cabin, his foot bound up with filthy rags. I went back home for some carbolic wash and some iodine. Upon my return he unbound his foot. To my horror the ghastly wound was distinctly green in color. At once I had my suspicions.

"What did you put in that cut?" I asked.

"Auntie Rose tell me to put three cents in it, and tie it up," he told me.

Forcing copper pennies into a wound and tying them in is a favorite treatment among rural Negroes. In this case gangrene had set in. I got the man to a hospital in Charleston, where he survived the amputation of his leg.

On another occasion I was horrified to have a young Negro come to me with the hilt of a knife standing rigid between his neck and shoulder. He told me that he had been in a fight, and that his rival had driven the little keepsake there. It had been in the wound three days.

But I have never been a complete skeptic about superstition, for always, it has seemed, there must have been a reason for its origin. Often, too, a beauty and a dignity attend a so-called superstition that render it noble.

For example, when for the first time a plantation Negro baby is taken outdoors, the occasion calls for a religious ceremony. The mother walks toward the door with the child in her arms. Beside her walks another member of the family, talking *to the baby's spirit*, for fear that when it comes under its native sky, the soul may suddenly return home. The spirit is told what a beautiful, joyous and wonderful world this is, in order to reconcile it to its sojourn on earth.

A believer in mystery, I find something here that may be true, and even if it is not, there is nothing in it to call forth mirth or scorn.

Plantation Negroes have picturesque ways of accounting for human phenomena. For instance, there is their legend of the Walk Off People.

It appears that on one occasion Adam, deeply troubled, sought out God in the Garden of Eden.

"God," he said, "you know how I love to catch fish in the river, and to hunt rabbits. But Eve, she's complaining. She says she gets lonesome because I fish and hunt so much. She's talking of leaving me."

"That's easy," said God, "come down to the creek with me, and we will make a few more people. They will keep Eve company while you are away from her."

Arriving at the water's edge, God shaped some new people out of mud, and leaned them against a rail fence to dry.

"Adam," he said, "I will come back before sundown and put some brains in them."

But God, forgetting that He had some other engagements that afternoon, did not return to finish His work until the next morning.

Before that, the people with no brains had walked off! And they have been increasing and multiplying ever since!

It always does me good to discover for myself, or to hear firsthand, something fine about any other human being.

It was with the superintendent of an iron furnace located in Ohio that I was talking. He had been describing the building of a new furnace, in the construction of which the best masonwork is essential. "I never in the world would have finished on time if it hadn't been for two bricklayers from Alabama," he said. "They did more work and better work and they worked more cheerfully than any other men I had. They were Negroes trained at Tuskegee."

Twenty-five miles southeast of Norfolk, on a lone stretch of the Virginia beach, I was talking with a solitary white fisherman, the owner of a huge fishtrap—an arrangement

of nets of formidable length and strength, extending far
out into the raging surf. Among the sand dunes were some
shacks where, he told me, the fish were packed on ice as
soon as they were brought in from the trap, a half-mile off
shore. I say he was alone, but there was a boatful of men
along the net, and another at the trap. As we stood watch-
ing them, the second boat, evidently having acquired a
load of fish, set off for the shore. There were eight men in
her, all Negroes. Manfully they oared their twenty-five-foot
boat, burdened to the seats with a heavy catch, and, as the
craft came reeling in through the breakers, I heard the men
singing. Singularly appealing was the whole scene: the wild
and solitary beach; the plunging breakers; the single white
man standing with me on the shore, like a guiding intel-
ligence for his workmen; certain ospreys and a bald eagle
hovering over the grim fishtrap; and the daring fishermen
bringing the overloaded and unwieldy craft in through the
treacherous surf. And they were singing. I thought of
Noyes's "Forty singing seamen in an old black barque."

"They are all Negroes," my friend was telling me. "You
can hardly get a white man to stay down here and do this
kind of work. But these men are cheerful and strong, and
they are good seamen. Besides, they never give me any
trouble."

Geographically we shall move southward four hundred
miles or so. The scene is a huge cottonseed oil mill on the
outskirts of Charleston. Here four hundred Negro men are
employed. There are perhaps six white men in the plant.
My brother has been the superintendent here for nearly
fifteen years. Often he is the only white man in the mill,
and the mill stands remote from all other places of in-

dustry. Here he employs his four hundred men. Here, if you will go with me, you will see them: yardhands, singing at their work; mechanics in the engine room, with that deft skill of their craft writing its lesson of intelligence and care on their open features; here in the pressroom, stripped to the waist because of the great heat, are powerful specimens of the black race, toiling without respite. Everywhere there seems to be good cheer, hard work, understanding and often a human sympathy and mutual regard deepening into affection.

And this is one more picture. A rice planter has died. For a generation he has been a wise man and just, kindly, humane, generous. To the Negroes he has been more than an employer. He has befriended them in a thousand ways. Often he has denied himself to share with them the little that he has. They have always counted on him, loved him, trusted him. And now he is gone. What do they do? For miles they come to do him honor. They come, the young and the old, to show their genuine affection for a genuine friend. What can they do? They might be of some little help, at a time when most human help seems a vain thing, but they do not really help. Their grief is too great. "The whole trouble was," wrote one who saw the scene and who described it to me, "that the Negroes were crying so much that they seemed able to do nothing else. I have never seen people so inconsolable."

Often at night I have stood on a tall bluff overlooking the broad reaches of the lower Santee River. That vantage point affords the finest of all views of the tremendous delta. And the scene is most memorable at night, having about it a vastness, a reticence, a mystery akin to eternity itself. Be-

low me stretch the quiet waters of the great river, mirroring myriads of brilliant stars; northward and southward the mighty stream retires—northward into the moldering swamp, southward toward the waiting sea. Far down the river I hear the boat songs of Negro shad fishermen. Beyond the limpid and mystic river stretch the vast waste fields of the delta country, the lonely woods of that melancholy fair land. But one touch is needed to make the scene magic, and this is supplied by the rising moon. With a sorcery divine she floods the tall bluff with light, casting her streaming argentine beauty over the delta, upon its sibyllines writing the scattered dreams of her sorrow and her glamour. And all that beauty and mystery become lyric in the voices of the fishermen. Few, indeed, are the races who sing while they toil.

There is, I think, no lovelier land than the old plantation regions of the Carolinas—a land of hyacinth days and camellia nights. Nature there triumphs in giant trees, in great rivers, in lustrous fragrant fields, in an exotic profusion of wild flowers.

And perhaps no one who was not reared in that rich and romantic country, so stimulating to the heart and to the imagination, can have any just conception of the influence of the Negroes upon the whites. That influence on me was profound; but of course I could not estimate it or understand it during my boyhood.

I shall now attempt to tell something of the plantation Negro's religion as I knew it at Hampton—a view adjusted somewhat by maturity and by a familiarity with other types of Christianity.

In any country in which a state religion is displaced by a multitude of jealous sects, there is sure to be much professed in the name of religion to move the thoughtful to grim mirth and soulful disgust. In our country at this time we seem to have a different kind of religion for every color and for every rank in our secret and chaotic caste system. And this confusion tends more powerfully to repel the discerning from the church door than to attract him to any sanctuary.

Religion is a primitive instinct, and perhaps it is among the primitives that it is most genuinely practiced. Surely the Indian who took a forthright satisfaction in slaying his enemies and yet who adored with no halting heart the Great Spirit is closer to God than the supposed Christian who robs and browbeats his neighbors for six days, and then appears on Sunday as a pillar of the church of society.

Wearying somewhat of cathedrals, and of creeds, and of the vanities of the world in possession of sanctuaries, I am turning for my appreciation of true religion, to a very humble people, living the lowliest of lives, far from the madding crowd. I am turning to the plantation Negroes I have known and loved since childhood. In some unmistakably genuine essentials, if they are not close to Christ, no one in the world is any more.

A strange combination of circumstances has rendered this effect possible. Brought to America a slave, the Negro of my part of the country became the servant of English Cavaliers and of French Huguenots; and in these ruling classes the Protestant religion came in America to a flowering approaching mortal perfection—which is to say that,

though it had its faults, it was astonishingly sincere, adequate and salutary.

It was fortunate, as Edgar Allan Poe pointed out, that the slaves became the property of Cavaliers rather than of Puritans, not that the latter were in any way inferior to the former—only that they were different. The Cavaliers (and the French Huguenots shared their qualities) were generous, high-spirited, indulgent, used to a superior station, accustomed to command with kindness, capable of inspiring deep loyalty and deep affection. The Puritan was less intent upon spending his heart in the kindly offices of neighborliness than he was sternly bent upon strictly placating a terrific and black-browed Jehovah. The Puritan's life was reflected in the austere snows, the frosty starlight, the bleak wintry landscape of New England. The Cavalier's was interpreted by the roses, the camellias, the serene climate, the jasmine charm of the far South—where life often has an almost mad and sobbing beauty, an insufferable ecstasy of peace.

The Negro brought with him to the South a dim sense of God, an awareness of the Vast Invisible, a deep superstition, an oriental acceptance of life as mystery and fate. Among his white masters he encountered a religion of quiet affection, of gentleness, of all that makes human association endearing and ennobling. He became a Protestant; in many cases he became a Church of England communicant. A study of the records of some of the old Southern parishes will reveal the strange fact that thousands of slaves were church members. Their masters, wise and compassionate, were careful to minister to their spiritual as well as to their physical welfare.

But the fact of this admission to high spiritual fellow-ship was perhaps less remarkable than was the capacity of the Negroes genuinely to assume it. Apparently they un-derstood—and they tried to live by the religion of Christ, as that was expounded to them not only by their masters, but as it was exemplified to them daily in the lives of their gentle and refined masters. All parents have imposed on them the grave necessity of living in such a manner that their children may safely follow their example; this same sense of responsibility the masters felt toward their slaves, who, it was soon learned, were swift to discover the vices and virtues of those above them, and as swift to imitate either evil or good behavior. Wickedness in a superior ap-pears to sanction, or at least to condone, sin in an inferior. If, therefore, the white man's religion helped the Negro, the Negro's presence assisted in sustaining the white man's behavior. The child disciplines the parent often more pro-foundly than the parent the child.

Being an oriental, and coming in contact with Christian-ity, which, it should always be remembered, is an oriental faith, the Negro found it easy to perceive and to accept the heart of Christ's teachings.

When we consider the religion of the plantation Negro we come to a religion identical in essentials with the Prot-estantism of early America, with the faith of the Fathers of the Republic, with the sacred belief of refugees and pioneers in wilderness parishes of the year of grace 1700. The plantation Negro still has unimpaired this beautiful and noble faith. When I contrast it with the hectic brands of our hoofhearted and feverish civilization, I feel like one who, famished in the Sahara, comes to an oasis, with deep

shade, cool palms, crystal waters, heavenly assuaging of mortal need.

The Negro I know is not only uncontaminated by civilization in its grosser material aspects, but he has not been at all captivated by the spectacle of those abortions of religion by which our age has been so speciously regaled: by mountebank ministers who (for almost as large purses as prize fighters get) perform physically for the amusement and the pruriency of their venal congregations; by the bawling fury of revivalists, who will undertake to convert anybody (temporarily) for cash; by brass bands in churches, and imported ungodly singers; by the transforming of God's sanctuary into a social emporium; by the convenient substitution of hilarious picnics and comforting suppers for a broken and a contrite heart.

In short, the Negro I know has not been misled by spectacular substitutes. He seems still to feel—so sadly is he behind our brave advance—that religion is a sacred, a secret, a personal relation between his heart and the life of God, and that all else masquerading as religion is vanity. He is too wise and profound to be impressed by outward fabulous show. I doubt if Negroes will ever build a cathedral, not that they will be incapable of doing so, but rather because they will not be convinced of the spiritual necessity for it. And we know that the effect of architecture upon behavior is not significant. One does not go to a cathedral town to study superior morality.

One day I was lamenting to old Anthony Lee, the patriarch Negro of my plantation flock, the fact that his people had never finished the spire on their little church.

"Ah, Cap'n," he said penetrantly, unmoved by my con-

cern, *"here* is the true temple." He pointed to his heart.

All my life it has been my privilege to be instructed spiritually by Negroes. Saint Joan, amid the roaring fagots, looked upward saying only, "Blessed Jesus." There is enough in those words to lead humanity to redemption. But I would place beside them the last words of my beloved Prince Alston, a Negro who was my comrade for forty years. He died when his family had great need of him, when he was happy, when he did not wish to go. "Now," he said calmly, "I am going to my heavenly home."

If every good churchgoer could so pass, I should have considerably more faith in the church in civilization.

One day I was lamenting to an old Negro the death of two of my dearest friends. He heard me in silence, and I observed that his expression had in it less of sympathy than of disappointment.

"How, Cap'n," he asked when I had ended my sorrowful tale, "ain't you got no hope?"

It was a just rebuke, prompted by a deep religious sense.

To me it has always appeared that a simple faith is far more natural to people rurally environed than to those amid the artificial palaces of civilization. From the dawn of history shepherds and herdsmen and woodsmen have been natural worshipers. Lying from birth on the ample sweet bosom of nature, nourished at those fragrant breasts, they who are country dwellers never find it hard to sense the nearness and the power and the love of God; whereas the city dweller, surrounded by the work and the power and the imperfections in character of man, are less free to feel God with them. So, at least, it seems to me.

Now, the plantation Negro walks barefooted and bare-

headed through the twinkling dew and under the white stars. He is almost as essential a part of the landscape as the great pines, the lordly river, the druid cypresses, the fragrant-with-fecundity black loam. He seems molded for a place in plantation life by the great Mother. Sometimes when walking the woods with a Negro I feel that he is the proprietor, I the visitor.

Because his superstition is still with him—and how beneficial superstition can sometimes be—the plantation Negro's religion has in it a pagan, perhaps a pantheistic, strain, which is by no means a poor foundation on which to rest Christian faith. It would be well for fundamentalists to recognize that the worship of nature and the worship of nature's God go hand in hand; and that he who worships the God of the universe is usually ready to accept Christ as the Son of that God.

I never knew a Negro atheist or a Negro freethinker. This race is by instinct religious. And out of its heart has issued, like the Miserere of the pines, one of the two types of genuine lyrics indigenous to American soil—the ballads of the mountaineers being the other. The popularity of the spirituals and the consequent commercializing of them have tainted them somewhat with artificiality. There have been dance-hall versions of these classics; and some recent plays have owed their popularity to the rendering of spirituals by fairly competent singers.

But he who would hear the true spiritual, and come, through hearing it, to an understanding of its power to interpret the Negro's religion, must hear the spiritual at its source. I have often listened not only unmoved but somewhat bored to the rendering of these matchless lyrics

by trained voices which have, in attempting these partic-
ular songs, one fatal defect: a conscious twang of restraint
and civilization, the inhibitions of city life. But I never
listen to them when they are sung in plantation solitudes
without being profoundly affected by the wild, mournful,
abandoned, soul-gushing-forth melody of the spirituals.
Then I hear Sam Gaillard's tenor, grieving like a lonely
night-sounding bugle; and Sue Alston's rich contralto, full
of violins and moonlight, and flowing as naturally as a
deep stream in a fragrant meadow; and Florence Colle-
ton's harplike soprano, choiring like a voice celestial; and
Steve Boykin's velvet bass, rolling out in soft melodious
thunder. There is no other music like this; there can be
no closer contact established between the human heart and
its Creator than by these moonlit crystal bridges of song,
built by love and by eternal longings. . . . They mean
more to me, far more, than all the *Te Deums* of all the
proud ministers.

Yet it is not the melting melody alone that makes the
spirituals appealing; it is the fact that I see manifested
everywhere the loving-kindness of the Negro to the Negro
that makes me love his religious songs.

In a village church I once sat next to a comfortable com-
placent white butcher, who notoriously shortchanged all
his friends and neighbors. With stentorian dissonance he
bawled the hymn, "I am Jesus' little lamb." He sang what
he did not mean, or feel or understand. The Negro sings
because he is incurably religious, and he takes his religion
into real life.

Very touching to me is the faithful solicitude with which
plantation Negroes "visit the fatherless and widows in

their affliction." With pathetically little to give of things material, they are spendthrifts of heart—which is, perhaps, life's final wisdom. With infinite patience, unselfishness, and affection they nurse the sick, visit the sorrowful, cheer the disconsolate and help to recall the straying. I do not know that the religion of the mighty Dreamer of Galilee calls upon any human being to do more than that.

And the Negro has been good to me. For me he has performed a thousand obscure and touching fealties. He is continually going the second mile. I have Negro friends to whom I have often trusted things most precious to me. Not one of them has yet betrayed that trust.

Leaving the plantation one Christmas Eve for a visit with some neighbors, I told my Negroes that they could go home at seven o'clock. . . . On my return, after midnight, I found them waiting for me, with lamps and fires lighted —and at the same time depriving themselves of a most tempting Watch Night service in their own church. . . .

Not infrequently I learn the true meaning of *fidelity* by becoming aware of a Negro's faithfulness.

Perhaps there is no sensitive and reflective mind that does not have its times of doubt, its fears over the reality of faith, the reasonableness of immortal hope. . . . I wish that all such spirits could know the religion of plantation Negroes; it does not make them perfect, for human perfection is not attainable. But anyone who will bring to these dusky humble children a heart receptive to light will surely have the shadows of his soul softly illumined; gentle hands will lead him out of a darksome country; lowly sweet minor voices will hush his spirit with a music whose quiet tide seems setting toward eternity.

Chapter 6
Black Woodsmen

NEARLY all the rice planters of the old South loved hunting, especially deer hunting, and they took their sport after the English fashion by riding to hounds. Early was I bred to be a hunter. Among the most remarkable Negroes on the plantation were those, and are those, who learned woodlore from nature, and taught it to me.

Living as I do in a vast wilderness, almost primeval, and among neighbors who love field sports, I hope to be a good woodsman. Nor could my father ever understand why— as some visitors hinted he should be—he ought to be ashamed of this hale and manly pastime. I remember that when he was training me for the woods, he often told me that a sportsman brings home more than he kills.

There are a lot of sentimentalists who think of the sportsman merely as a killer, and their erring imaginations picture him as going forth to slaughter and returning home lugging with him dead animals and birds and fish. They regard his activities with aversion, and they condemn him, sometimes in speech and in writing, sometimes by scornful silence. I have sometimes found myself in company where my interest in field sports has been regarded as sin and shame and crime are ordinarily regarded. For these critics I feel more pity than resentment, for if they could only know what a true sportsman really brings home they might

come to a just appraisal of the littleness and the sterility of their own souls.

And what are these things that we bring home? Sometimes we bring trophies of our prowess with the rod and gun; and no reasonable human being can deny that these are natural and legitimate fruits of our efforts. We teach our children to read stories of Daniel Boone and Davy Crockett, and we regard them as American pioneer heroes; but somehow, when we of this generation seek to imitate their feats, we are regarded in some quarters as barbarians. For my part, I love to enter a home where there is a deer head hanging; it makes me feel that a real man is around.

We bring home our game—when we are fortunate; and if that were all we brought, I should still be proud of a race that produces hunters and fishermen, and I could never experience any feeling of guilt in considering their achievements. But we bring home much more, and only true sportsmen know what those things are.

A sportsman brings home more than dinner for his family and trophies for his den; he brings home a body toughened by hardy exercise and disciplined by following the rules of an ancient and exacting game. He returns to the world of work and of care a better man physically. He has renewed his youth. It may be that he has added years to his life and to his effectiveness as a toiler among men. He has recaptured in the wilds something of the spirit and the strength of his boyhood. He goes into the woods with two strikes on him, and he comes out ready to knock a liner clear over the center-field fence for a home run.

Oh, I know that the sentimentalists say that these same beneficent effects can be had by hiking. I would not say

anything against hiking, but it is as much like hunting or fishing as a mother-in-law's kiss is like a bride's. You simply cannot classify them together.

In hiking, you go out and you come back. When you hie yourself into the wilderness with your rod or your old blunderbuss, you are playing a game; and in this game your antagonist is not the wild creature you are after. He is the prize. You have many antagonists to overcome before you win that prize: your own weakness of will, your inclination to give up, adverse conditions of weather and of terrain, a run of bad luck, the acute disappointment over those near chances that never really become chances. In brief, your two main opponents are wild nature and yourself.

And when you came back from a hunt or from a fishing trip, you feel more of a man, not necessarily because of what you have killed or caught, but because you have put yourself to the test against those forces against which only real men will enter the lists. Your confidence in yourself is restored. You can take it. And the appetite you bring home makes your wife wonder whether she has not, after all, married the caveman of her secret dreams.

But you bring home more than a better body. You bring back a mind from which the cobwebs have been swept; a mind keen, alert, hale and wholesome; a mind that refuses to accept sofa lounging and tap dancing as forms of manly endeavor; a mind reconciled to the daily grind, and ready to tackle the next problem with courage and confidence. You bring back a better husband and father; or, if you haven't gone so far as that, you bring back a better lover. Show me the girl who loves a sportsman, and I'll take off

my hat to her. She knows more than some of her elders, and her natural devotion is deepened by an ancestral preference for a mate who has some hardihood in him. Every community is better for the sportsmen in it; every woman is better for having married a sportsman; and every child is fortunate who has a sportsman for its father.

The true sportsman also brings home what never can be taken from him: he brings home memories that make all life different, even to the very end. He thinks of the true comrades he has made, friends who could have come to him nowhere but in the woods, on the plains and by the streams. He brings home the recollection of those modern pioneers whose homes are in the wilderness—people whose hospitality he has shared. The memory of them serves to redeem humanity for him. He brings back a knowledge of the creatures of the wild—a knowledge that the hunter alone can gain. He remembers their resourcefulness, their courage, their sagacity and their obedience to the great laws of nature. He brings home with him the beauty of the elder world, the fragrance of primeval forests, the laughing light on crystal streams and the tattered gold of autumn leaves.

These things enter his spirit and abide there. Because, far back at the eternal source of things, he has heard a voice saying that all is well, he gives less heed to calamitous voices of civilization. In the unsullied silence of the deep woods he has heard the true and steady heartbeat of life, unwearied since creation. He is reassured by finding no change in the order of the universe. He comes home with a sense that the beauty which God created is going to stay created. He has found for himself that at the fountain of

life the waters are still flowing. He has learned what he could learn in the wilds alone: that he is no stranger on the earth, but a legitimate son who is privileged to share a great inheritance.

Yes, a sportsman brings home infinitely more than the game he may have taken: he brings home a saner, finer and stronger self.

While many of us are familiar with the tributes paid by white hunters and explorers of the Dark Continent to the black guides and trackers of Africa, and while most of us are familiar with the admirable bedtime stories of animals told by the inimitable Uncle Remus, I do not recall any tribute paid the American Negro as a woodsman. Since he is highly gregarious by nature, it is not indeed as a woodsman that he is generally known, but in the flowery wilderness of the Deep South, especially in the regions of the old rice plantations, he sometimes came, and sometimes still comes, to an extraordinary degree of proficiency in the elementary but fascinating business of matching his wits against those of the creatures of the wilds. All my life I have associated with Negro hunters, trappers and fishermen, and when one is really good, he is, I think, at least as good as an Indian. He appears to be able to do what the white man cannot do: he is able so to orient himself instantly that he seems to be thinking on the plane of the wild thing. We can sometimes blunderingly anticipate an old stag's next wily maneuver, but the Negro hunter appears to know what a buck will do before the deer himself does. A profound psychologist of human nature, he understands birds

and animals in a manner superior to ours, for all our learning.

During my long plantation life I have learned to respect and admire this gift of the Negro. Most Negroes have it in some degree, but I have known a few in whom the quality became a kind of genius.

When I was a little boy on the plantation, one of the real personalities I knew and revered was Old Galboa. Throughout my boyhood this old woodland sage was to me all that was wonderful as regards knowledge of the habits of wild creatures, and all that was ingeniously skillful in the matter of outwitting them. He knew his game. As a slave and throughout the rest of his long life he had been the professional fisherman and hunter for the plantation. His sole duty consisted in supplying the family with venison, wild turkey, wild ducks, bass, shad and oysters. Game and fish of all kinds were very plentiful, but of course it was game, and therefore very wild. But if given an order, Galboa would fill it. The difference between him and Uncle Remus was that, knowing the wild things and understanding their wiles, he had no need to invent anything in order to be interesting. By the hour I would sit with him while he regaled me with tales of his adventures in the woods and on the river.

In the long history of fishing along the lower reaches of the great Santee River, Galboa was the only man who knew how and where to catch the superb rockfish. How he discovered where these fish were to be caught was a secret that he would never divulge. But there were many things about wild creatures and their ways that he did teach me.

A past master at stalking the white-tailed deer, he told me that when two bucks were feeding together, both of them would never put their heads down to browse at the same time. One would always act as a sentry. "And you must watch the watchman," he would say. He also told me that in the summer, when gauze-winged flies are a pest to all animals in the woods, deer are in the habit of seeking out dense sweet-gum thickets; there, before lying down, they will rub against the aromatic leaves, turning round and round, until the sweet oily odor permeates the air. This keeps the flies away. A keen observer, he said that whenever a deer is about to make a movement of any kind, he will invariably twitch his tail first.

There was one bird that Galboa was afraid of—the great horned owl, the tiger of the woods. But it was not on account of this predator's strength and ferocity; it was because this bird, almost alone in the avian kingdom, has a note that is highly ventriloquistic. Mournful and eerie, one cannot tell from where the sound is coming. It was this unnaturalness, suggesting the supernatural, that Galboa did not like. He believed that during the hours of darkness the powers of evil may be exalted.

Galboa always gave to the wild turkey the highest place that can be assigned to wild intelligence. He told me that if a man stayed perfectly still in the woods, and if the wind was right, a deer might walk, unknowing, within a few feet of him. But not so with the wild turkey, which can identify a man far off, even if he is motionless. Although he did not kill wild turkeys until the late autumn, he built, during the summer, the blind from which to shoot them.

"You must give them a long time to get used to seeing

it in the woods," he explained. Furthermore the blind—usually constructed by making a square or circular wall of brush and trash about four feet high and four feet in diameter—must never be made all at one time. It must be built up very gradually. So keen is the wild turkey's sight and so high is his intelligence that he will notice and become suspicious of any new or unusual object in the woods.

Galboa told me that not only would a turkey notice something new but he would miss something old, so that he was always careful not to displace any logs and not to cut any bushes near the blind. Finally it was Galboa who suggested to me the fine human psychology in calling the wild turkey. He told me that he considered this bird a great aristocrat, and, in calling the gobbler, the hunter has to call as little as possible. There has to be allurement, shadowy avoidance, mystery, a suggestion of nonchalance. If the hunter calls too much, he will disgust this patrician of the wilds. Just like a man, this great bird does not like a member of the opposite sex to throw herself at his feet. He has to be vamped, lured by siren wiles.

Galboa was a genius in handling animals. He never beat them, but talked to them in a way that soothed and made gentle their harried spirits. Wise, subtle to understand the secrets of nature, and yet somewhat inscrutable, he was quick to recognize the nature of a problem with an animal, and usually quick to solve it. But if he could not handle the situation, he was frank to admit the fact. Once I took him a gun-shy bird dog, with the petition that he cure the dog of his grievous fault. After ten days I went back to Galboa to see what had been accomplished.

"Little cap'n," he said, with the calm finality of one who

has accepted defeat, "nothing can be done about a fool."
I have always thought that that observation has a far wider
application than a canine one.

What Galboa told me about birds and animals was true,
for everything he said I have been able to confirm during
the more than fifty years that I have roamed the wilds.

Gabriel Myers, to whom I have already referred as an
expert with the broadax, now more than eighty years old,
has roamed the woods with me for more than half a cen-
tury. He is tall, black, certainly handsome and, I think,
distinguished-looking. About his noiseless ambling walk
there is much of the Indian. He is the greatest trapper,
white or Negro, I have ever known and, while of late the
law against the use of steel traps has cramped his style some-
what, he remains what he has always been—an extraor-
dinary woodsman. Gabe has trapped the pinelands, the
swamps and the moldering morasses of the delta. He has
caught otters, minks, wildcats, raccoons, opossums and
foxes. He says that the wariest of all things to trap is the
otter. It is excessively shy, very intelligent and so fastidious
about its food that it does not readily take bait laid in its
path. Besides, being more at home in the water than on the
land and often wandering far from base, the otter is very
difficult to get localized, so to speak. Then, like the raccoon,
the otter will gnaw its leg off in order to escape from a trap.
Finally, such is this beautiful creature's prodigious
strength and such its fighting spirit that no ordinary trap
will hold it.

Gabe tells me that the opossum is the most stupid of all
wild creatures, and consequently, the easiest to trap. If you

set a trap, an opossum appears to make a point of getting into it. Gabe once showed me how he set a trap for a fox. In about an inch of sand he buried the trap in a fox path. Above the trap he hung a dead mouse on a heavy strand of spider web. In a shallow hold beside the trap he laid a half-burned sweet potato. For reasons unknown to me, the odor of such a potato is, to a fox, quite irresistible; nor could Gabe tell me how he discovered that this lure was effective. He explained the spider web by saying that in dealing with wild creatures you must try to keep everything looking natural. For the otter and the mink, he baits with fish; he sets for the raccoon near his den tree. When I asked him where he usually set his traps for a wildcat, he said, "Close by my chicken house."

Woodsman Gabe has always been a shrewd observer. He told me that once in the early summer he had seen an old mother fox coming down a path, her four cunning cubs behind her. He was well hidden at the time, and was quite near their line of march. Picking up a little clod of earth, he tossed it at the mother. It struck her in the back. Thinking that one of her youngsters was getting fresh, she turned angrily and cuffed the two foremost—much to their hurt surprise.

Gabe gave me a good piece of advice about venomous snakes. "When you are in the woods, never step over a log until you look first on the other side." Rattlers lie lengthwise along the base of a fallen log, and close to it, in indolent ambush.

Gabe has had some fearsome encounters with venomous reptiles, and he has taught me much about them. He told me that, in our country, the very worst place for diamond-

back rattlers is an ancient graveyard in the woods, where the moldering brick tombs offer perfect places for hiding and hibernating. He first pointed out to me the straight deep track, like a trough through the sand, of the diamond-back, the serpent terror of the Western world, justly called by the Seminole Indians "the Great King." When I was just a boy, Gabe found for me and showed me the nest of a great crested flycatcher, the only bird that hangs a dried snakeskin out of the hollow where it rears its young—some think to make it simulate a snake den, in order to frighten away all intruders.

Once Gabe brushed against a huge copperhead, lying coiled on top of a tussock in a swamp. The reptile struck downward at his foot, but instead of reaching him, it buried its fangs in one of its own folds, drooping from the side of the tussock. That snake killed itself with its own venom.

One day Gabe brought me, nonchalantly slung over a pole, a rattler and a king snake, wrapped in fatal combat. The beautiful king snake, being a true constrictor and apparently immune to the venom of the rattler, always wins in this kind of battle. We laid them on the ground and pried them apart. The rattler crawled away with much injured dignity. After he had gone about fifty yards and was no longer within sight, we let the king snake loose. With one-third of his black-and-white body high off the ground, resembling a cobra in posture, he swiftly followed his prey. When we came upon the two again, they were once more in the same fell embrace. The king snake is a very valuable species, as he destroys the coral snake, the

rattler, the copperhead and the cottonmouth moccasin—all our venomous reptiles.

Gabe is old now, but he is still a woodsman. So close to nature has he always lived that when his passing comes, it will be but a gentle sinking more deeply into those arms and upon that bosom that has always cradled him.

About four miles from me, on the eastern borders of the mighty Santee Swamp, lives a very old Negro friend of mine, and a most remarkable woodsman. This is Phineas McConnor, who, as his name would suggest, deals with wild creatures with a canniness that could be nothing but Scotch. Phineas is small, and physically he is frail. But he has extraordinary nervous energy, thinking nothing of walking twenty-five miles in the wilderness on a day's hunt. He has developed a power of self-effacement in the woods, so that he is almost like the witches in Macbeth, who "made themselves air, into which they vanished."

Once when I asked him why he always seemed to get close to even the wildest game animals and birds, he said, "I outquiets them."

Phineas is a real human personality, unique and always interesting. A felicitous raconteur, he is a matchless mimic, and when he tells me a story of the wilds, he acts the whole scene out, gesticulating like a Frenchman, imitating the sounds made by birds and animals, even taking off their vagaries; and all the while his eyes are dancing and his quick and infectious laugh gives to his tales the lightness of comic opera.

Like his father, West McConnor, Phineas knows alligators. He taught me how to catch one without a hook. He

uses a stout wooden stick about four inches long, sharpened at both ends, the middle having a groove around it. The line is tied on this groove, and the stick thrust lengthwise through the bait. An alligator will literally eat anything, but he considers squirrels, rabbits and large birds great delicacies. In proportion to his size—I have measured a bull sixteen feet long, weighing about sixteen hundred pounds—the 'gator's throat is very small. When he swallows the bait, a tug on the line turns the sharpened stick crosswise against the back of his throat.

Phineas hunts alligators as a professional. I have had him sit beside me on the bank of a lagoon, where, calling as if a dog were barking, he would lure one of these great reptiles almost up to us. He it was who told me of the alligator's peculiar habit of swallowing, before hibernation, an indigestible substance—a stone, a pine knot—apparently to keep the digestion mildly stimulated during the long winter's nap.

I have never known another woodsman who could so accurately distinguish each one of the multitudinous sounds of the forest. He once asked me to listen carefully to a clear flutelike whistle that I was certain was human. "A wild turkey," he said, and, sure enough, pretty soon a flock of these regal birds came along, and I saw the bird that was giving this deceptive note. He taught me that rabbits drum on the ground with their hind feet in order to signal to their fellows. He told me that in stalking game he had constantly tried to avoid being seen by squirrels, for they are the alarmists of the woods. If a squirrel—having the advantage of being at a height on a tree—gives a bark

of warning, every other wild creature within hearing instantly becomes alert.

One day Phineas and I were passing under a huge live oak. We suddenly and simultaneously stopped, for we heard the insistent and arid song of death from a rattler's bells. I scanned the ground all about us, but saw nothing. Then I noticed that Phineas had cocked his head and was peering upward. "He is in the tree," he said. "See him lying on that limb?"

Stretched full length on one of the oak limbs was a big diamondback. Phineas got a long pole and dislodged him. So great was his weight that he made a tremendous thud as he struck the ground, and he was fighting mad. After he had been dispatched, Phineas said, "If you have a gun or a rifle with you and meet one of them, you hardly have to take aim. He will take aim at the muzzle of the gun." I have tested the truth of this remark many times, and certainly one of these venomous serpents, if aroused, will always align his head with the aim of the woodsman.

Once when Phineas was coming to see me, he came upon something that he wanted me to observe. One of my fields lies close to the river. Sandy, sheltered and inviting, it is often resorted to by birds that want to dust themselves. Phineas told me to hurry if I wanted to see two old wild gobblers taking a bath. Literally crawling on our stomachs, we came to the old rail fence and peered through. Not far off stood one of these patricians of the wilds. But I saw one only. This I whispered to Phineas.

"Only one washes at a time," he explained. "The other watches."

Near the first bird I now saw a cloud of dust rising as

the gobbler fluffed out his feathers and wallowed in the warm sand. After four or five minutes he arose, shook himself thoroughly, and then assumed the statuesque pose of a sentry while the other bird relaxed and then lay down in the sand to wash.

When I walk in the woods with this lithe and wary Negro, I always feel somewhat clumsy. He always sees and hears things first, and the noise he makes is no louder than that made by a cat in crossing a carpet.

Unwearied by life, full of vigor and of fun, as enthusiastic as a boy, Phineas does me good in many ways, but perhaps chiefly because he serves to remind me that, in pioneer days, most Americans had his spirit. And it is heartening to find it today as I have found it in Woodsman Phineas.

A fourth Negro from whom I learned much about nature was one who is no longer with me, my comrade, Prince Alston. We were of the same age, and for a generation we were inseparable, enjoying a woodland fellowship that brought us very close together. As boys, we shared a thousand adventures in the deep plantation woods, the wide plantation fields, the deep and strange plantation waters. I developed into an amateur naturalist; Prince became a peerless woodsman. He brought to his understanding of birds and animals, wild and tame, a certain occult comprehension that no white man ever attains. He appeared to regard all beasts and birds as his younger brothers and sisters, and he spoke to them and of them as if he shared all their hopes and fears. In all this was something of the

mystic's fathomless far reach to the heart of God. Nothing in nature appeared too small to escape his notice.

My association with Prince Alston had been lifelong. He was the son of Martha, for forty years our plantation cook, and of Will, for a longer period our wood bringer and fire builder. Prince and I were of the same age. But his infancy, though he was supposed to be relatively unimportant, was far more dramatic than mine. Nature often seems to overlook with the most exasperating candor many of those very distinctions upon which we most fervently insist. One day, while I was sleeping in my carriage in the front yard, Prince was being plunged, in the back yard, into a huge caldron of hot pea soup. He thus early attained over me an ascendency in point of authentic interest; and, although I was supposed to be the master and he the man, perhaps he has maintained it to this very day. I owe him much. For forty-four years our comradeship lasted, and it was one of deep affection. For my part, I see no reason for the termination of it, either on this or on the other side of the grave.

Prince's affair in the caldron happened quite naturally. His mother reported to mine that the baby had a "spasm." Recognizing at once the child's desperate need, and knowing that an immediate plunge into warm water is the best first-aid remedy, my mother called for hot water. None was forthcoming, but Martha suggested that in the back yard peas were boiling. My mother, with little Prince in her arms, hurried down the back steps. Before her under a huge live oak was the momentous-looking caldron, just beginning to steam gently. After dipping in her finger to determine the temperature of the water, and finding it

tepid, she laid the black baby among the steaming pea pods, holding him gently but firmly in place. Almost at once his crying stopped. Prince was saved. Moreover, a certain glamour was shed over his infancy, and for years he went under the strange and distinctive appellation of "the Pea-Soup baby."

Prince's inheritance was a good one, I mean his spiritual inheritance. His mother was possessed of a primeval faithfulness and affection, and his father of an almost heartbreaking humble loyalty. And his son Prince has always had that kind of spirit in him.

Through childhood and boyhood my Black Prince and I were inseparable companions in a thousand plantation escapades; we were thrown from the same woods pony at the same time; we were together pursued by the same infuriated bull; nearly drowned in the same pond when our canoe upset; and in the matter of gleeful butting, the half-wild goat that we had captured made no distinction between us as victims for his sinister jesting. Whenever our frolics came to the attention of the elder generation, we were equally reprimanded. My father repeatedly scolded us as one, especially on the occasion when we knotted together the tails of two semiwild boars that were feeding at a trough, with their backs close to a convenient hole in the fence. And Henry Snyder, the Negro foreman, a very superior person, for whom I early acquired a dreadful respect, used to be very severe with us—chiefly because we delighted in ruffling his oppressive dignity.

Our worst offense occurred on the day when, after borrowing a set of deerhorns from the frieze in the hall, and draping two deerskins over us after the manner in which

the Seminoles camouflaged themselves while deerstalking, we burst into the barnyard, where scores of Negroes were threshing rice, superintended by Henry. We charged the crowd with wild, weird shouts, scattering madly the gravest and most sedate of them, especially Henry, in whom, as the leader of his clan, a peculiarly high and sensitive kind of superstition had been developed. Henry's ability as a runner, jumper and general escaper had never been publicly demonstrated before, but he showed on that day the power to lead, in rather magnificent style, a precipitous retreat. We paid dearly for our fun, for to make a man lose an assumed and cherished dignity is of all insults the most deadly.

But mischief did not occupy us wholly. We planted a little garden together; we had scores of curious pets, such as alligators, raccoons, fawns, foxes and minks; we rode together after the cattle; visited the solitary spacious pine-woods to get lightwood for the fires. We also, from earliest times, hunted and fished a good deal together, though I cannot report that we supplied the plantation table with commendable regularity. Our failure to do so was not due to any lack of fish and game, but rather to our discursive natures, for no sooner were we well started on a hunt, or well settled by some cypress-brown, bass-haunted lagoon to fish, than some new interest of the wildwood or of the wild water would divert us. Thus I remember that we spent a whole half-day trying to see how many deadly cottonmouth moccasins we could catch with our fishing tackle. We did well, but when we presented our catch to Martha, in a somewhat darkened kitchen, her reaction was decidedly volatile and picturesque.

Young as I was, even in those first years of my association with Prince I recognized in him a decided superiority in certain matters. A plantation Negro is as close to nature, I suppose, as any man in the world, and close in an intimate, authentic sense. He is still a child. Folded on that ample bosom, he hears and obeys the voice of the ancient mother; he has with marvelous accuracy what we slangily but felicitously call the "low-down" on all the creatures of nature. The knowledge of them that came to me in some small degree after many years of patient observation and study, Prince appeared to have instinctively. His understanding of wild things was not scientific, but natural. I have always noticed that he spoke of an animal as if it were a human being; he fixed no gulf between the two neighboring kingdoms. His eyes in the woods used to surprise me; now they amaze me. My own eyesight has always been normally good, but it does not clairvoyantly apprehend as does his. As boys together, he was almost invariably the one to warn me when I was about to step on a snake. He could take me to the spot in the sunny wild field of broom sedge where a little fawn lay. He could see, on the topmost tiny spire of a towering yellow pine, that wisp of gray that betrayed the presence of a scared fox squirrel. It was he who took me to the den of a huge bull alligator on a lonely island. He had heard that Minotaur roar, had discounted all the ventriloquistic quality of that weird bellow, had located the singer accurately, and to the formidable monster he guided me, when he was not more than eleven years old. We caught the huge reptile, Prince and I, with a hook and line. We drew out Leviathan with a hook.

Because of our close and genuine comradeship, I used

to go to Prince's cabin about as often as he came to my home, and as we were together every day and usually until nightfall, the one would go halfway home with the other. The way led through the woods, and along the edges of the melancholy plantation burying ground where, for more than two centuries, the Negroes of the place had been interred. There the mighty pines towered tallest; there the live oaks stood druidlike; there the jasmines rioted freely over hollies and sweet myrtles, tossing their saffron showers high in air. As children, Prince and I dreaded this place. I can remember going along this dusky road many a time, my love for him taking me farther from home than my reason warranted, his love for me overmastering his fear of the graveyard, so that often he used to come with me all the way to the plantation gate. We used to walk that road holding hands, and even now I can remember how the hands of those children, one black and one white, used to tighten as a dewy strange wind gushed by us, or as an owl would begin his haunting twilight note.

All things human change, and the time came when a temporary parting was inflicted upon Prince and me. I was sent away to school and to college; he remained in his old wild free life. His prospect looked to me as halcyon as mine was foreboding. It was years before we were able to renew our companionship. When opportunity was once more afforded us to be together, we were both grown. Whatever, in a deeper sense, my growth had been, I do not think that essentially it was very far in advance of his, and certainly in physical development he had immeasurably surpassed me.

Whence got he those mighty shoulders? Whence came

that iron grasp? Whence got he that huge and rugged fore-arm, that splendid depth of chest? Though not of great height, his stature, leonine and massive, would set all the athletic coaches of America agog if they could have seen it. While I had been delicately pursuing French verbs to their dim lairs, and trying with many a headache to determine whether Pragmatism is a true philosophy and Relativity a true scientific theory, Prince had been felling forests, digging canals, driving mule teams, and, with the sun at about 115°, he had been plowing down knee-high crab grass, shouting and singing as he worked. Standing to the thighs in fetid, snake-haunted swamp water, all day long he had sawed huge cypress logs, he and his fellows laughing and joking as they toiled. Or out in the lonely forest of yellow pine, from daylight to dark he had brought thundering to earth the giant trees, tall as masts of brigantines, and full of nameless aerial melodies in their crowns.

Black, rugged, independent, Prince was a man long ere I became one. Years and other matters had parted us, but when we met, we clasped hands with the old affection, and perhaps understood each other as perfectly as two human beings ever do. Death's is not the only veil through which we cannot see; an impalpable arras separates most of us. The human soul seems a shrouded thing, and most solitary. Love alone is capable of destroying isolation and of breaking down every barrier.

That Prince was a real psychological study I have, of late years, come deeply to appreciate. There was, for example, his mastery of animals, which had in it a spiritual legerdemain fascinating to behold. No man who watched this Negro with dogs or mules can be persuaded that magic

is dead. On occasions that are literally countless I have shamelessly referred to him dogs that were of the most incorrigible sort, dogs that would not even make up with me. Immediately he would establish a definite relationship with them, partly by firmness, partly by kindness, but chiefly by an occult and complete fathoming of the dog's mentality. I recall how he made Blossom mind him when she would pay me not the slightest attention.

This hound was new and strange, and Prince and I took her into the woods for a ramble. Young, diffident, headstrong, she was prone to race pell-mell after any alluring scent that assailed her delicate nostrils from the damp sandy road. We were in wild country, and to have her escape on a trail would have been serious. I was about to suggest that we put her in a leash when she suddenly left the road on a dead run. A fresh buck track explained her joyous haste.

At thirty yards a shout from Prince brought her to a bickering halt. She was too far away for him to catch her, or even to threaten her effectively with the long lash that he carried. The hound did not want to come back. Yet, while ignoring me, she deigned to give Prince a bright, undetermined look, as if inquiring politely the reason for his impertinent interruption of her urgent business. Knowing that it would be a vain thing for me to try to lure the dog, I left it all to him—I usually left anything to him that was difficult—watching closely to discover by what mental artful sleight he would accomplish the miracle. Clearly, it was to be a spiritual, not a physical, struggle.

"Blossom," he called, "come here, child. Here, Blossom, come here to me. You is the prettiest, fines', most 'bedient

houn' I ever did see. That's a good girl. Come on now.
Come on, honey Blossom. I know you wouldn't leave me
here in the road all by myself. That's a sweet Blossom."

Flattering wiles, couched in tones that reached the
hound's very soul, accomplished what force and anger and
less delicate deception could never have done. But there
was more than that to the performance. Into the immense
solitude environing the individual Prince had suavely
obtruded himself. All creatures will, I suppose, respond
to blandishments, but they must be of the intimate and
understanding variety. The hound Blossom was com-
pletely taken by Prince's tones. She turned toward us.
Then she approached step by step, a little contritely. At
last she made a little run, frisked about Prince, leaped up
on him affectionately, licked his hand. I had had, in col-
lege, a course in Practical Psychology, and one in Animal
Psychology. But my knowledge had left me helpless,
whereas Prince knew what to do without ever having been
taught.

Watching Prince handle the biggest, stubbornest mules
in a timber camp, I came to believe that the secret of his
mastery over them arose from his ability to establish in
them a definite conception of their inferiority. He then
took it for granted that they would work, his attitude being
objective, hale and natural. He talked to them also, as it
were, in their own tongue, and to his raillery they re-
sponded with astonishing willingness. To manage mules
should be accounted something of an artistic tour de force.

I remember the first time I ever saw Prince operate on
a stubbornly planted mule. It happened down in a little
seacoast village near home. A farmer's mule, hitched to an

infirm and staggering wagon, loaded heavily with a Saturday's purchases, had made up his mind that the prospect of seven long sandy miles ahead did not appeal to him. The animal balked in the middle of the village street, right between the post office and the general store, so that the performance created considerable stir. At such a time, all local and loafing celebrities are exceedingly fertile in advice. To this scene of hopeless *status quo* Prince and I arrived after some very heroic measures had been used without the slightest response on the part of the immobile mule. He had been cruelly beaten; his harness had been taken off. The wagon had been rolled back. But there he stood violently rooted, with a certain exasperatingly virtuous expression on his countenance. Curses and shouts left him unmoved. Even a small fire built under him had had no effect at all as a persuader to progress. The city fathers had become less assured of tone as one after another of their solvents for balkiness failed. The affair had come to a state of impasse when Prince stepped quietly forward, while I watched fascinated. He approached the mule with gentle assurance, and insinuated one arm around the stubborn neck. His touch was affectionate. Putting his mouth to the mule's left ear, he said something to the miserable statue. Instantly the creature rigidly relaxed, and almost blithely the mule stepped forward from the position which for more than an hour he had sullenly maintained. When Prince came back to me, I asked him what he had said to his friend. The Negro only laughed, for he never seems to take seriously any of his feats with animals. But his must have been the magic words having the exact wave length of the dull creature's obscure and baffled soul.

For many years I had searched in vain for a specimen of the black fox squirrel, a variant in color of the gray. It is in reality a color due to a condition known as melanism. Mentioning to Prince one day my wish, I was surprised to have him say, "I show you one today." Together forthwith we went to the woods. It was mid-March, and the leaves gave the forest an emerald-misty look.

Prince took me up a long watercourse through the woods where grow many tupelos, gums and redbud maples. Ere we had gone a half mile we had seen gray fox squirrels, big handsome fellows. Each one was in a maple tree. At last my companion pointed to what I should have taken for a spray of dead Spanish moss. It hung almost drifting from among the ruby buds of a maple. It was a fox squirrel, black as ebony.

"How did you know it was here?" I asked.

"He been here las' summer," Prince answered, "and the year befo', when he was a baby. A fox squirrel," he added, "this time of the year will come a mile or mo' to get the redbud."

Woodcraft of this kind Prince gathered during those years when he was a worker of turpentine, and no kind of toil is more exacting in the matter of compelling the worker to traverse almost every foot of the forest. He must literally go from tree to tree. Being a keen and accurate observer, and not only seeing but actually entering into the lives of the children of the wild, he had gathered an astonishing amount of firsthand information about nature, and this knowledge, like all information acquired through experience, had become a part of his character. Many men use their knowledge of nature merely as an intellectual

decoration. This Negro guided his life by that knowledge and by those ancient laws. Because he did live by those laws, ordinary physical obstacles had for him no substantial existence. Long since he had learned, without any mechanical device, how to annihilate distance.

One afternoon I said to Prince that he and I ought to go deer hunting the next day at daylight. I could see that my request embarrassed him a little. But he said he would join me, adding, "I will be back by then."

"Back?" I asked. "Where are you going?"

"I have to step up to Jamestown," he answered.

This place is twenty-three miles from home, and swamp miles, too, over corduroy roads which are usually inundated. Prince walked the forty-six miles, most of them in the dark; and at daylight the following morning he was in the plantation back yard before I was up. In fact, what woke me was the joyous yowling of the hounds which announced the arrival of their beloved lord and master. Prince thought nothing of walking twenty miles to buy a plug of tobacco, a pound of bacon, a sack of flour. And usually in making his journeys he did not follow roads; as short cuts he knew all the animal paths through the forest. When he needed wood, taking his ax, he went to the pinelands, perhaps a mile or more from his cabin, and would return with a massive section of a lightwood log on his shoulder. He did things directly, quietly, in nature's way. When I read stories of Negroes who are little more than minstrels, I do not recognize in them blood brothers to my Black Prince. Though superstitious in a piquant way, as all elemental human beings are, he was not afraid of the dark. Moreover, without being able to name a single star,

he could guide himself by them; and, lacking starlight, he retained an uncanny sense of direction even in the deepest woods at night. Well I remember the time that he and I, taking an acetylene lamp, went to the forest to try to discover and to count the deer that we could "shine" with the light.

It was late October, and the dying year was beautiful as only lovely things departing can be beautiful. It had rained that afternoon, and as we set out on our expedition, a sodden yellow evening with sallow lights was faintly gilding the ruined trees. Pale lilac gleams suffused the fading woods. By the time we had left the inner plantation bounds, night had come down, starless, occult, mysterious. Before we had gone a mile farther, our blazing light had disclosed for us five deer, airy shapes of the fabulous darkness, delicately roaming the forest. I was wearing the lamp as a headlight, and it disclosed to us not only the deer but our own surroundings as well. Prince said he knew where we were, though we were in virgin timber a long way from any road. On we went, deeper and deeper into the double night of the forest and of the darkness. I heard the muffled joyous gurgling of a stream; the earth deliciously exhaled dewy odors. Other odors there were too, strange and pungent. Suddenly on my arm the hand of my woodsman closed like a vise.

"Cap'n," his soft voice said, "step back this way."

I obeyed, knowing that he had detected something that I had not.

"I smell a rattlesnake," he said. "I think he is in them huckleberry bushes ahead. We must go around him."

It may be that I owed my life to Prince that night, but I

doubt if he even remembered what I so vividly recall. I can still feel his hand, hear his voice. It was a voice I infallibly trusted. It was a human voice that had never deceived me. Its tones were akin to the tones of nature.

Not far from that patch of bushes that we wisely avoided, my light began to sputter. Then something behind the glass flared, blinked, and was gone. In vain I tried to rekindle the flame. We were in abysmal darkness, there in the far-off silent woods, inhabited by creatures less appealing than deer. I was as lost as if an airplane had dropped me in the Brazilian wilderness. But I did not have the sense of being lost, for I had with me an infallible guide.

"Do you know where we are, Prince?" I asked.

"Yes, sah, I know."

"Can you find the road?"

"Yes, sah."

"How do you know which way to go?"

"My mind done tell me."

By the expression "my mind" a Negro does not mean his thinking capacity, nor yet his knowledge. He seems to mean his prescience. At any rate, in a half hour we were back in the familiar plantation road. It was not that we had been actually delivered from any special peril, for with daylight we could have found our way. It was rather that Prince demonstrated to me that he had a sense of direction that would function even in the profoundest darkness, and there's always something miraculous in one person's doing what a supposed superior cannot. Here, indeed, was a child of nature. And there was no more pretense in Prince than there is in a good black furrow or in a boulder or in a sunrise.

Of him as a spiritual human being, I had no misgivings. I knew his heart too well. But most wives are exceedingly dubious concerning the state of their husband's souls. It was so with Prince's wife. She unburdened herself to me one day.

"Prince is good," she said in her gentle, compassionate voice, "but he cannot acclaim himself a Christian."

"Why not?" I asked, surprised.

"Because," she said thoughtfully, "he is a deer hunter. With Prince, deer hunting is religion."

But her subdued indictment of her husband was delivered with a faint smile, with a patient delicate tinge of humor, as if the future state of her sinful deer hunter did not seriously alarm her. As a matter of fact, Prince's faith would have put to shame the religion of many a supposed pillar of the church. The faith of this humble Negro was aboriginal, complete. How often have I heard him say simply, without a trace of professional unction, things like these: "God is good enough to do anything"; "The weather is so dry that I have a doubt mind, but if we trust in God, He will help us"; "God don't take no care of a man if he don't take no account of God"; "Cap'n, we gwine understand everything when we done reach the Promised Land."

About such a human being there is an atmosphere of permanence. He was one of the true inheritors of nature's bounty. When I would go home after all those years and find him there, he always impressed me with his changeless unspoiled quality, like that of a sentinel pine, or of the primal pagan night. Much of life is a matter of waiting, and partly for that reason we yearn toward the things in

nature which, like mountains and forests, wait with a lordly patience. Surely for the wild mortal heart to await quietly is an illustrious achievement. Prince had the ancient patience of the pioneer.

Some of the language that Prince used would not be easily apprehended by the ordinary listener. I have made little attempt to give his tones. They were musical and soft. And in addition to the "gullah" of the Carolina coastal Negro, he used a few words as strange as any ever heard in America. These were of genuine African origin, as their sound will connote. For example, when he says, "Cap'n, I yeddy one madindie in dem jubrocroo," he means that he hears a cottontail rabbit in the gallberry bushes. "De wedder giffie" means that the weather is uncertain. "Machinchie" means small; "bungiewala" means a dragon fly; "bofemba" means a swamp rabbit. It would hardly seem credible, and yet it is true, that Prince used often to say to me, when we were boys, "Let we go hunt dem machinchie bofemba an' dem blue bungiewala."

I owe to Prince what I hope is a fair understanding of life's deeper values. "I can still hear him say, "When I take a man into my heart, I can't hate him no mo'." I can see him in a freezing drizzle, far from home and at dusk, making easy in the lonely wood the bed of an old cow that is sure to die that night, and I know that such a man's religion is a living thing, prompting him to act. I can hear him going through the ghostly woods at night, whooping in a voice so melodious that it would charm a hardened critic, and I know that his spirit is wild and free and joyous. To get on into middle life retaining a free spirit is a thrilling accomplishment. To range the wildwoods singing, and

with the heart singing, is no light thing, for to do this is to be a child of God.

That I enjoyed the companionship of Prince must be apparent from all that I have said, but there are those of my acquaintances who cannot understand what I saw in this humble man that so deeply endeared him to me. To begin with, he had all the reticences that make comradeship possible. His life refutes the common but abysmal error that to be obscure and lowly is to be gross in word, thought and act. We were, of course, united by memories of old; we always loved and understood each other. What better bases for true affection can exist than sympathy and understanding? We belonged to different races. But we were brotherly. As I take it, the truest affection may exist between those who, naturally or adventitiously, are far removed in life's stations. In matters of the heart, all distinctions are impostures.

And if a man shall openly doubt the depth of affection that I felt for this modest comrade of mine, I am going to refer him again to John Randolph of Roanoke, who, after a long and distinguished career, declared that he knew no deeper and purer human affection than that existing between himself and the Negroes on his old Virginia plantation. That I, of a later and a far different day in the South, am sharing his experience is not (as I wish it might be!) a testimony of my spiritual kinship with Randolph, but to the essential humility, downright goodness, unfaltering faithfulness of the heart of the plantation Negro, as I have known and loved that type of humanity in Prince.

He first pointed out to me the daredevil aerial stunts of the swallow-tailed kite. In the springtime woods, when

we saw a wild turkey hen, apparently undisturbed, rise and fly far through the forest, he told me that this mother would nearly always fly to and from her nest, so that no fox or wildcat could follow to her precious eggs the scent left in her tracks. He told me what I believe few ornithologists know—that the blue jay buries nuts and acorns, just like a squirrel. Once when I wanted to kill a loggerhead shrike, he restrained me, and a little later showed me two small copperheads and a cottonmouth moccasin that this bird had killed and impaled on thorns. Picking up a dropped deer antler that had been lying for a year on the ground, he showed me how it had been gnawed almost in two. "Wood rats," he said, "maybe a squirrel. A cow will suck one of these a long time just to get the lime in it."

A fearless and skillful horseback rider, Prince did a thing one day that deserves to rank with great feats of horsemanship. I had wounded a buck, and he undertook to ride him down. The deer was heading into a hopeless morass, and if he was to be overhauled, the thing had to be done quickly. Running his horse full speed, Prince came parallel to the fleeing deer, whereupon he leaped from the saddle to the back of the stag and bore him to earth. I believe that even a rodeo audience would have applauded that.

One day he was standing with me when a noble buck stopped some distance ahead of us. There he stood in superb wild uncertainty, wary, sagacious, splendid. I asked Prince why he stood there like that.

"He is readin' his book," said Prince.

His book must have told him that there was danger

ahead, for when he gracefully moved off, it was on an entirely different course.

I have briefly referred to Steve as my valiant woodcutter. But I owe him for more than merely keeping me warm. He, too, is a woodsman, as you shall see, if you will join us on a little wildwood expedition. In our ancestral halls of nature, he knows his way around.

Steve has a favorite prayer that I have fallen into the habit of using myself, and its beauty and all-inclusive nature are best understood if one will remember how Negro cabins have a habit of staggering when they attempt to stand. Says Steve feelingly, "O Lord, prop me up in all my leaning places!" I find myself repeating this prayer whenever I get in a tight spot, especially in the big woods, as I did on that memorable February morning when I found myself amid a disconcerting number of wild turkeys.

It's a man's job at any time to handle skillfully one wild turkey, but when they start simultaneously coming to you from every direction, calling at every step, as if you were some fatal siren and they were poor human beings, why, I say it's being in a jam for sure. It almost makes a hunter feel that, instead of being after them, they are after him.

The afternoon before, on the advice of Steve, I had gone with him to Hampton Island, a wild area of some six hundred acres that is a part of my plantation. As it is little more than waste rice fields and overgrown banks, and little better than a watery wilderness, I rarely visit it. One reason why I am not keen about this hunting territory is because it is infested, at all seasons, with cottonmouth moccasins, and these truculent devils take much of the sport out of

hunting. But wild turkeys are on the island, and when food is plentiful they never leave it. So perfectly do they adapt themselves to that marshy and semisubmerged waste land that they may be said to have become semiaquatic, for often they spend the entire day in the reedlands and tawny morasses, returning to the timbered ridges only to roost.

During the late hunting season, so uniformly unsuccessful had I been with wild turkeys that I had set my dusky woodsman on their trail. If they are in the land of the living, Steve will find them; moreover, as they pay small attention to him, he never really scares them. It is a fact, at least in my country, that wild game is invariably less afraid of a Negro than it is of a white man.

Steve shambles amiably along, and deer and turkeys consider him harmless; he is, except that he relays news of their presence to me. It was so on this occasion. He said that he had been hunting hogs on the island (anybody's hogs) and had come across fresh turkey tracks in the old rice-field mud.

Here on the Carolina coast, along the great delta of the Santee, vast areas of former ricelands are overgrown to white marsh, duck oats, wampee, wild rice, smartweed and other aquatic foods. In almost impenetrable cover like this most of our turkeys spend the day. In addition to the foods supplied by the natural growths, they get a lot that is drifted in by the tides. In the late winter, when most of the acorns and other seeds are gone, they feed much on the young green of springing plants. I have killed a gobbler of the marsh in late February that had in his crop nothing but young marsh blades and wampee leaves.

Hopefully Steve and I ranged the island that afternoon, and I did see all the turkey signs a man could wish for. There were tracks innumerable, droppings under the great cypresses and water oaks, and on some of the ridges and banks whole acres of dead leaves were raked up in long windrows. For two hours we sat still, trying to roost a bird. But we neither saw nor heard a thing except countless gray squirrels and thousands of mallards coming in to the marsh to feed during the night.

At dim dusk we pushed our boat across the river and landed on the old Wambaw Bank, a huge earthen structure of pre-Revolutionary days, still strong and intact, and now grown to trees of immense size. We had hardly left the boat for our walk home when, right over my head, from out of a towering moss-shrouded cypress a gobbler pitched. He was closely followed by another. I did not see either one, but there was no mistaking what they were, and we could tell what direction they had taken.

I knew they would not fly far, and I knew they would alight in trees rather than on the ground, for when flushed from the roost at twilight a wild turkey usually makes an absurdly short fly and never alights on the ground. He may alight in a bare tree, presumably because he can see the branches. I have known a whole flock of sixteen, disturbed at dark, to fly not more than seventy-five yards. Taking Steve's arm, I whispered to him not to say a word, and we tiptoed away from the place. Under such circumstances, a hunt at daylight is the thing.

Let me add that, as far as my observation goes, of late years the turkeys are roosting more warily than they used to. Heretofore I often found them in comparatively bare

trees, with perhaps a little mistletoe or moss in them; but now, for their abode for the night, they appear to choose the most densely shrouded cypresses and yellow pines, trees so heavily hung with moss that I have repeatedly stood under one of them, knowing a turkey to be above me, yet also being unable to make him out. I believe that our turkeys travel considerable distances to discover trees suitable to their taste for roosting.

When we had gone far enough to make it safe to talk, I told Steve that by daybreak we should be back under the tree from which the two gobblers had been flushed. Thus it was that, while we got home with empty hands, we had a lot of hope in our hearts.

We left the house at 5:30 that mild February morning to walk the mile and a half to the magic spot we had in mind. There should be, I knew, more than those two turkeys that we had flushed. It was still, warm and very beautiful in the woods, which were awakening to light and to life. I spend much of my time abroad in the wilderness at this hour and at twilight, for one can see and hear things then that he will never see or hear during the garish hours of sunlight.

In the dim swamp that sloped away from the old wooded bank toward the river I began to look for a suitable place for calling. Such a place is hard to find. I mean that the turkey caller should not be too much in the open (so much, for example, that even a slight movement on his part will be detected by an approaching turkey) yet not so hidden that he has a difficult time seeing what is coming. It is important which way he faces, for if one of these great birds is

headed your way the slightest noise or movement will make him suddenly and radically change his mind.

At last I decided to sit at the base of a huge cypress, with my back to it, and about thirty yards from the tree on which the gobblers had gone to roost the night before. Steve, who had been shambling stealthily behind me, nodded approval of my selection of a stand, and eased off into the gross swamp. I had to smile when I saw him sit down against a black pine stump, a background that rendered him practically invisible.

Immediately before me was a thin screen of wild blackberry canes, with shielding moss draped over them. Just behind this screen was a small hardwood ridge. Behind me was a muddy swamp, densely grown to willows and alders. I know that it is sometimes bad policy to sit with one's back against a tree, but in this case I decided to face toward the place where the two gobblers had flown.

By the time I got settled, day began to dawn, all pearly and pink through the silent swamp, gradually tingeing everything with a roseate fairy light. Then, curiously, I heard a whippoorwill, for that bird is excessively rare here in the spring. Cardinals awoke, and Carolina wrens gave their rollicking calls. Marshhens cackled raucously from across the river, and chickadees began to radio their companions. Light was coming fast.

Taking out my beloved call, Miss Seduction, I touched her gently. Thinking at that time that I heard a slight noise behind me, I eased up cautiously to look. As I did so a masterly gobbler flew out of the cypress against which I had been leaning! He had been there all the time, camou-

flaged by the heavy moss, but I had not suspected his presence.

Especially in the dusk of the morning, a wild turkey will sometimes let you walk up under him, and this is commonly true if he thinks he is pretty well hidden. A wild thing enjoys as much as a human being a sense of security; give him this, and he will not rush away at your coming. I have walked within fifteen feet of an old tom curled up in dense brush.

Well, I thought, there are three big boys in this vicinity. I heard this latest gobbler come to ground far behind me, and, believe me, a big one can sometimes make a lot of racket doing that. I did not know whether I had disturbed him or whether he had come down of his own accord. As soon as he was on the ground I called again, at the same time looking at my watch. It was 6:40. I glanced off to my right and happened to see good old Steve, silent and inscrutable, trusting me. I must try not to disappoint him.

At that moment a thunderous sound came from the island—a long, low roar. The mallards and black ducks were leaving the marshes for a day in the salt creeks and bays down the river. For several minutes this little earthquake continued. Then all was still. Suddenly, behind me and a good way up the creek bank to my left, I heard a turkey. I answered softly, cajolingly. Oh, man! The whole country was full of turkeys! I heard them on every side of me. And they just happened to be in the right mood for calling.

I knew at once that this must be a good-sized flock, of which I had seen but three. The calm morning, the still wilderness, their own slight and unalarmed separation—all

these conspired to make them loquacious. Suddenly, from across the river, a gobbler came straight for me. But he was flying well above the tall treetops, and I did not want to spoil everything by risking a most uncertain shot at him. But he was a grand sight, sailing high through the red dawn on those wide and splendid wings of his. He went over my head and alighted on the Wambaw Bank in a high water oak, about two hundred yards behind me.

I heard four or five calling from the river bank on my left. Two were calling from the island immediately across from me. I heard one far behind me. Then one turned up right in front of me. There were too darned many turkeys!

I glanced at Steve. The whites of his eyes were slowly rolling. Gently and coaxingly I touched Miss Seduction. I felt certain of an early chance to shoot. But in hunting this great bird almost everything is unpredictable. I have known a wild turkey to give a hunter a chance by making a stupid break, but he would be a foolish man who counted on his bronzed majesty's making a mistake. When it comes to blundering, a wild turkey is less likely to be guilty than the hunter.

As soon as the gobbler in front of me began to call softly yet clearly, and I heard the turkey in the tree behind me calling him, I decided to quit my cajoling. I would concentrate on the one coming straight for me. It's all right to call a turkey, but if you really want one to come, let another of his kind call him for you. I knew that the turkey in front of me was coming right out to me and might step from the shelter of the swamp at any minute.

I put up my gun. At such a time a man should have his gun at his shoulder, for if he waits to make that motion

until the great bird is in sight, things may happen to make the hunter kick himself all the way home. For one thing, a wary gobbler is almost certain to vanish before the hopeful hunter can shoot—or at least before he can shoot with the accuracy essential in killing this finest of all game birds of the world.

So there was the layout: old Steve rolling his eyes; some six or seven birds now calling behind me—two across the river on my left; one straight in front of me—and all their yelps indicated that Miss Seduction had them in her power. They were closing in on me from every direction. And there was I, sitting flat, my call beside me, my gun up and ready for action.

I knew well enough that if I shot, the whole business of calling would be over for a long time. I only hoped that the rajah of the river bottoms was the bird coming straight for me. I had it all arranged very nicely. As soon as he showed himself I would collect him and go home in serene triumph. But weird things happen in the big woods, things which, years later, the hunter remembers with an ouch.

While I was concentrating on the ridge before me, without a sound to warn me, a big gobbler walked up behind me, right up to my tree, and started to walk past me—not an inch farther than three feet from me, and on my right. He had come through the swamp on the soft mud, and he hadn't made a sound.

Turkeys make a lot of noise when they are in the water —almost as much as deer—but the approach of this bird had been noiseless. The first thing I knew of his presence was his great head stuck around the tree; then, "Kut! Kut!" in wild alarm. And just as I saw him out of the cor-

ner of my right eye I made out a black shape ahead of me, but dimly outlined in the fringes of marsh that lined the swamp edges. He was the gobbler on which I had designs, but this other old boy had broken into the picture. And I knew that one "Kut!" of his would change the whole aspect of things.

As soon as he saw me he jerked back and then made a prodigious leap that was half flying. He didn't run and didn't fly, but he made a marvelous slashing high jump that took him back and away to the left toward the creek bank. Meanwhile the gobbler ahead of me had vanished, and any man who knows turkeys knows that my chances of seeing that gentleman again were slight.

But the big bird that had, as you might say, been eating out of my right-hand pocket stopped within range, though partly shielded by stout alder stems. So silent and spectral he stood that if I had not seen him go there I would hardly have been able to make him out. Without lowering my gun, I swung it slowly around until I got the ivory bead on him. Since he had sounded the alarm, I was not counting on seeing any other turkeys. I touched the trigger, and one of the old monarchs of Wambaw was down to stay.

Of the ten or twelve other turkeys near me when I shot, I heard not a sound. After I had retrieved my grand bird, a twenty-pound bird of the purest wild stock left in North America, Steve and I began our triumphant march homeward just as the rising sun was turning the broom-sedge fields to gold.

Said Steve, "Sometimes it is harder to kill a turkey when there is a plenty than when there is only one."

As I looked at the old strategist of the wilds slung over

Steve's broad and patient shoulders I was satisfied, even though I had killed the wrong gobbler. The one that was coming straight for me will never know how close a call he had, nor how it happened that one of his own mates saved his life.

To Galboa and to Gabe, to Phineas, to Prince and to Steve, I owe the debt due those who opened for me some of the pages of nature's gigantic green book. And the only gesture I can make toward the payment of this deep obligation is to acknowledge it.

Of what America will be in the days to come, and of what the Negro will be, I have no knowledge. Tomorrow in tremendous night reposes. I only know that the strength and beauty and glory of our country as we know it today have been in part due to a race originating in the Dark Continent, long held in slavery and now free to work out its own destiny. Its past has many glowing, if humble pages. If its future, with its infinitely superior opportunities, shall achieve even as much as its past did with its severe limitations, there will be made to our nation's history an inestimable contribution. At no time, certainly, could an honest and discerning chronicler of the annals of the land that we love have failed to pay tribute to the amount and to the quality of the work done in America by unsung millions of people like my Black Henchmen.

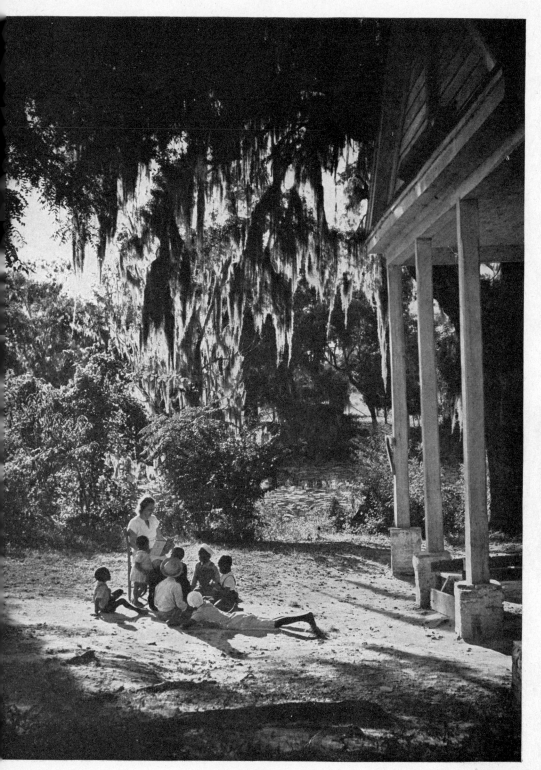

Eleanor's book club.

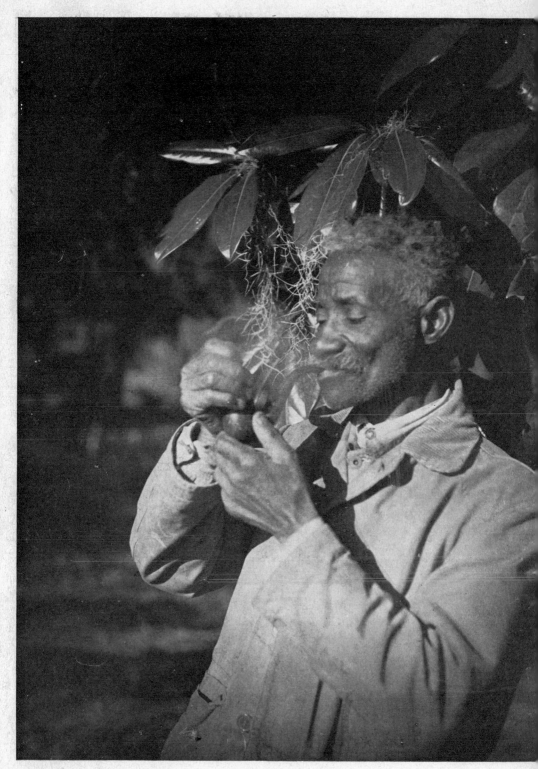

Old Gabe lights up.

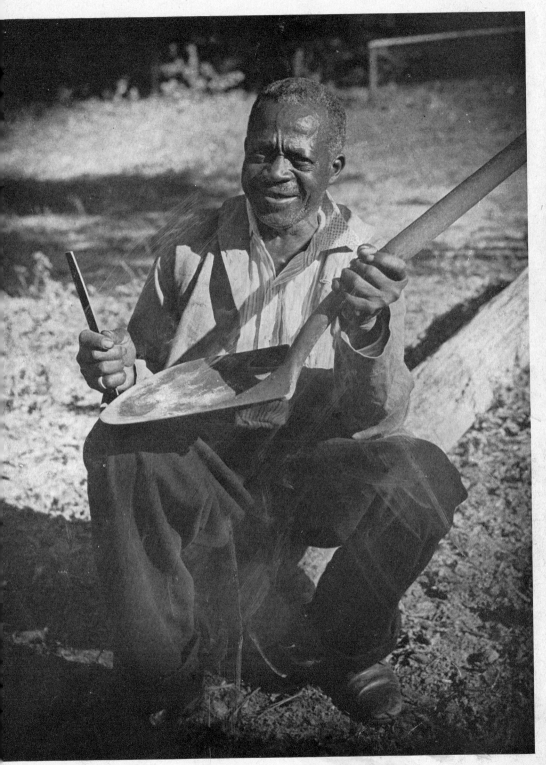

Alex Jones, who makes a shovel perform miracles.

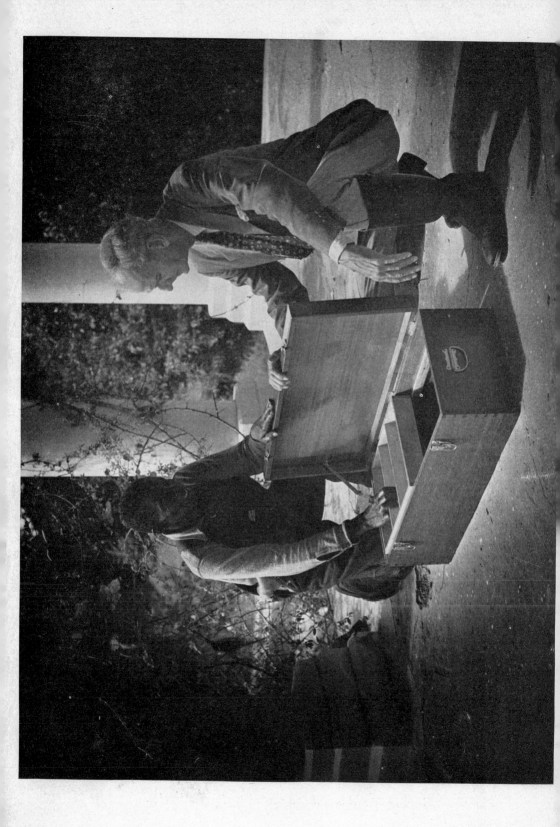

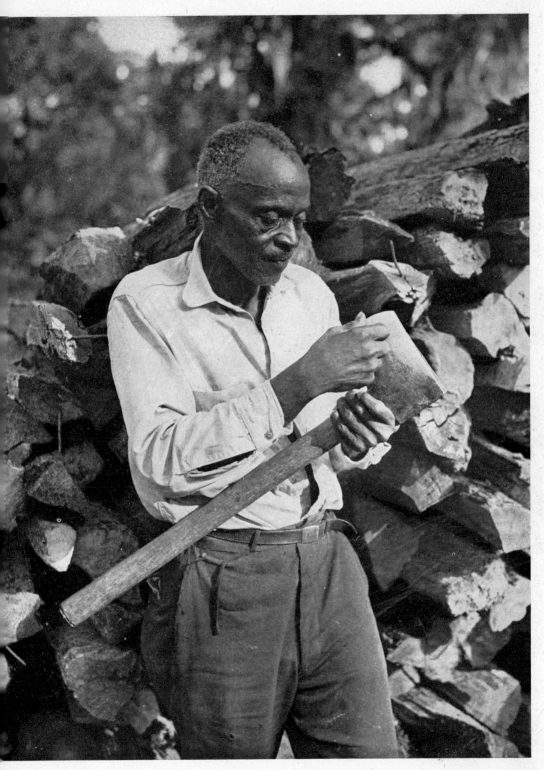

Steve Boykin, the master axman, testing his blade.

Giant plantation oak, 32 feet in circumference, and probably 1,000 years old.

Prince Alston enjoys the prospect of venison.

Sue Alston and her blind grandson, Lemon.

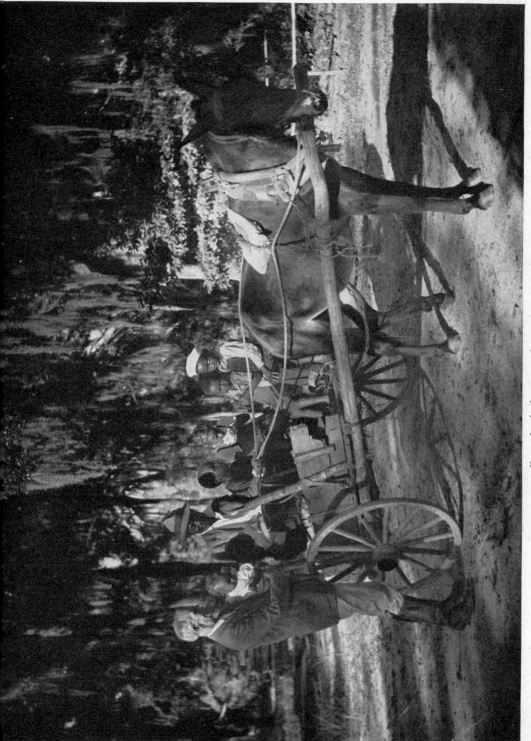

Everybody loves a plantation ride.

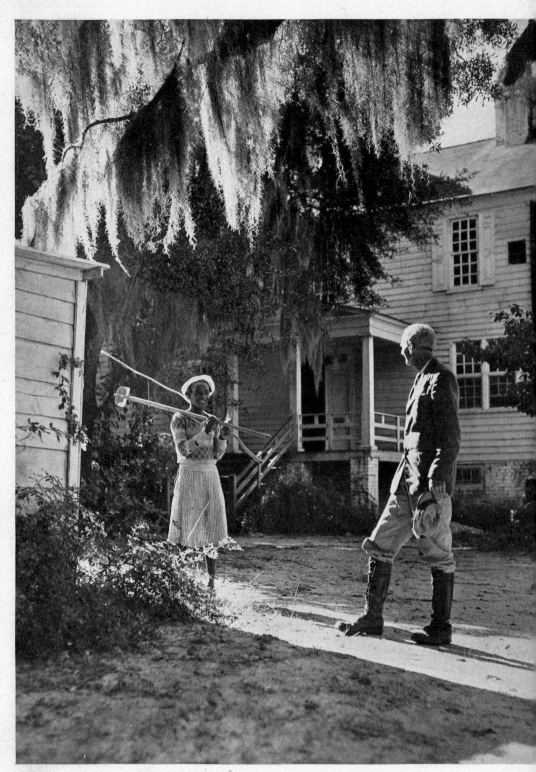

Julia, with hoe and fishing pole, arriving for work.

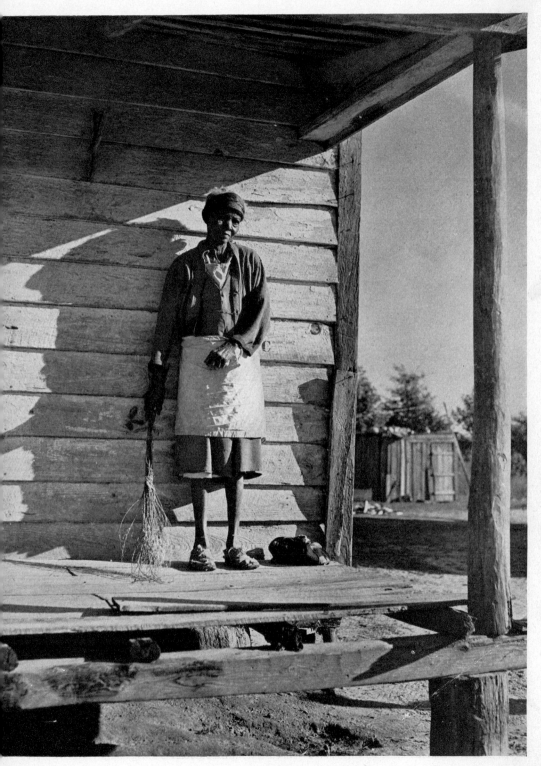

Kutzie German, plantation matriarch.

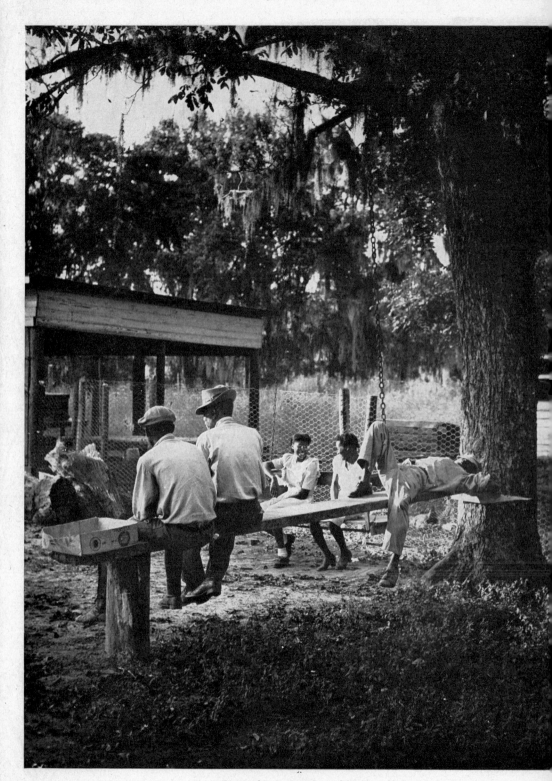

Plantation noonday siesta.

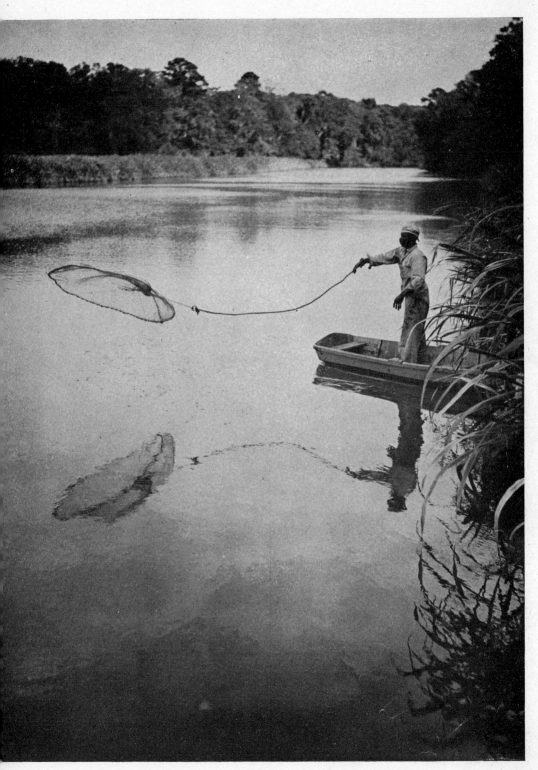

Will Alston trying to correct with a cast-net the fish shortage.

Sue rejoices over the canine harvest.

Beginnings of an education.

Sue Alston picking Hampton cotton.

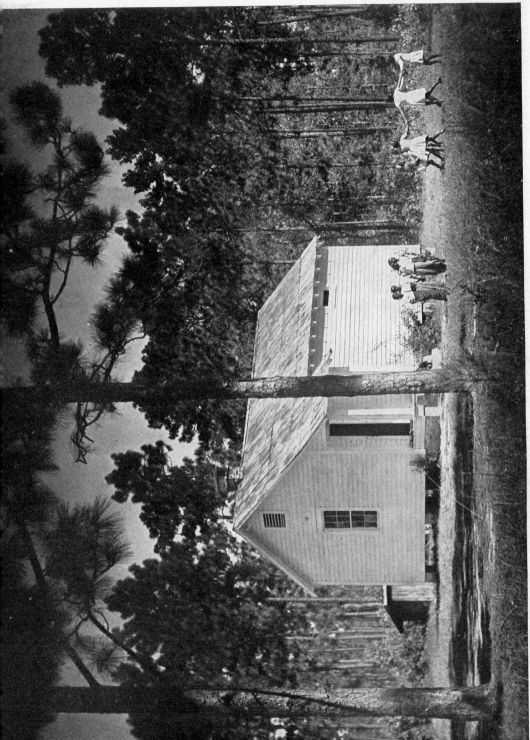

Children dancing during school recess.

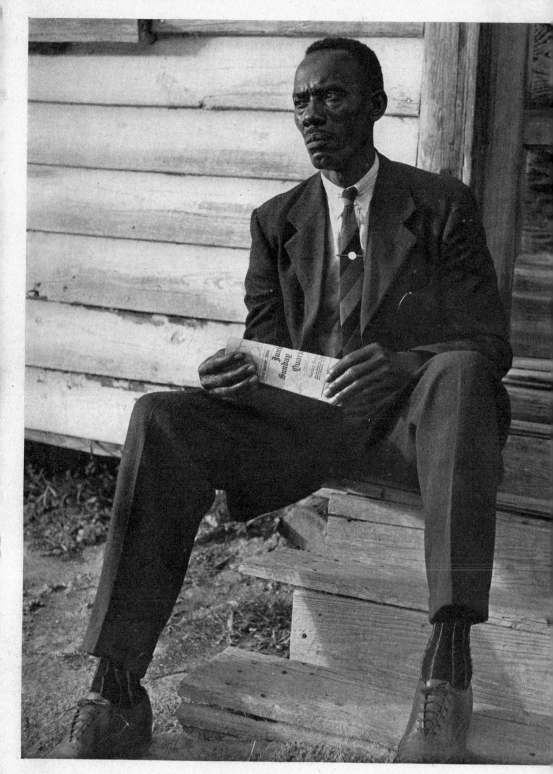

Isaiah, full of dusky wisdom.

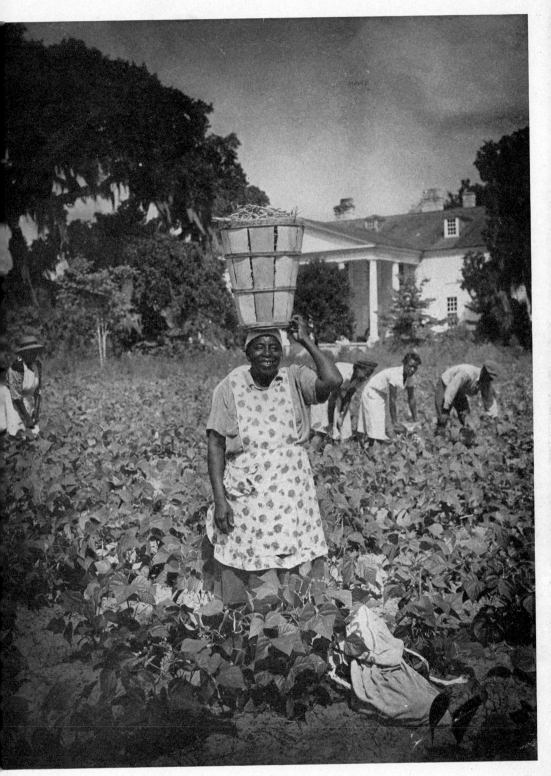

Betty balances a basket of string beans.

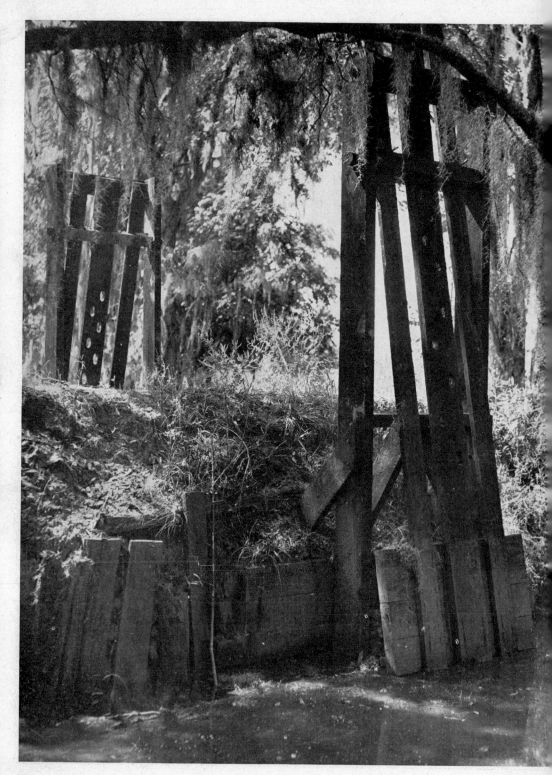

A rice field trunk or flood gate.

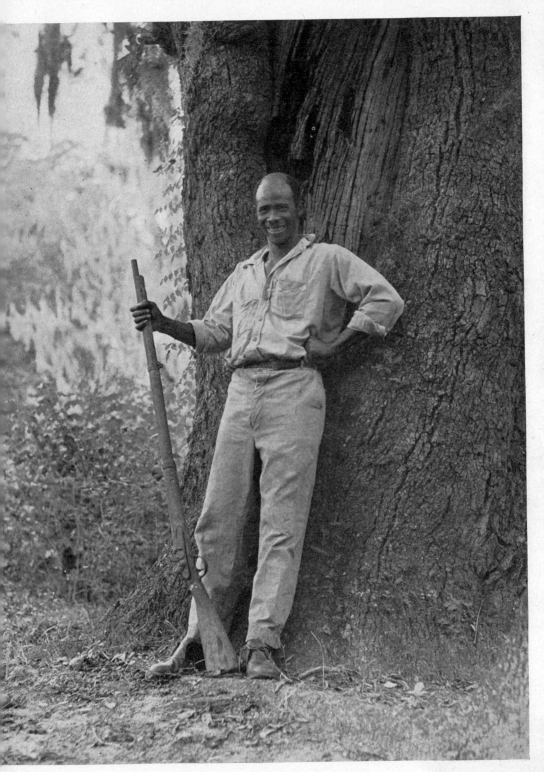

Mobile, swamp hunter, with his ancient musket.

Calling the faithful to church.

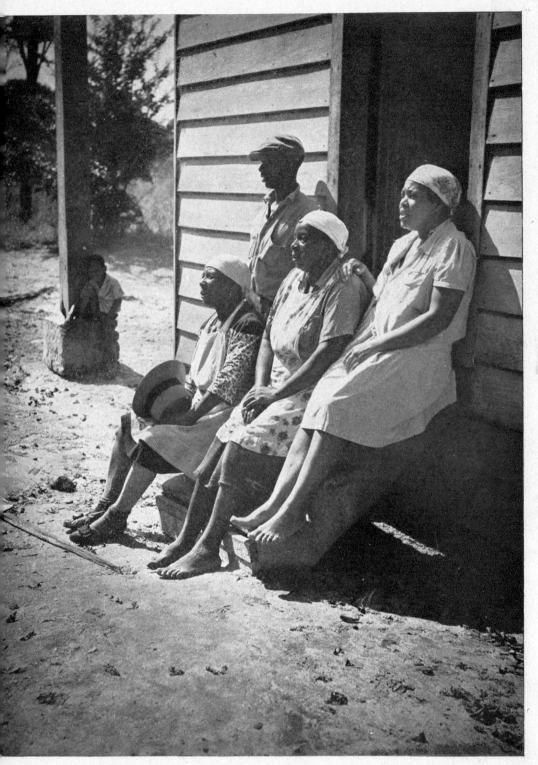

They sing as naturally as the sun shines or the rain falls.

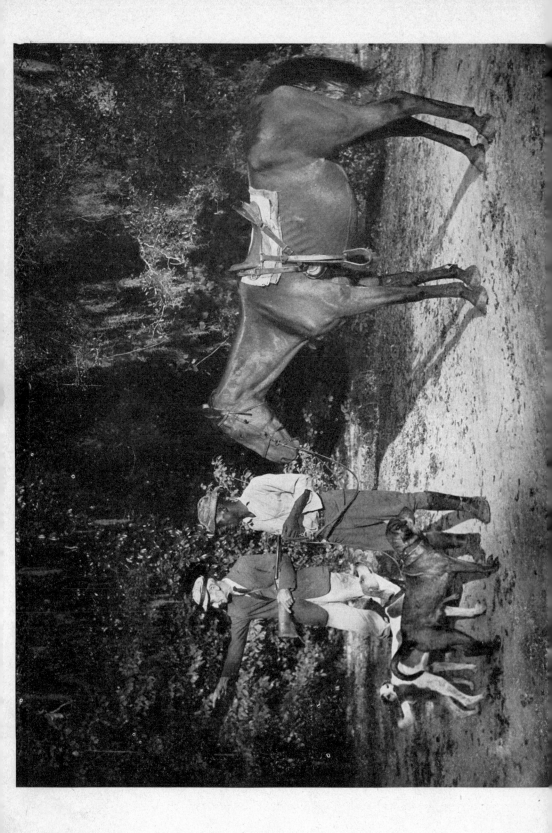

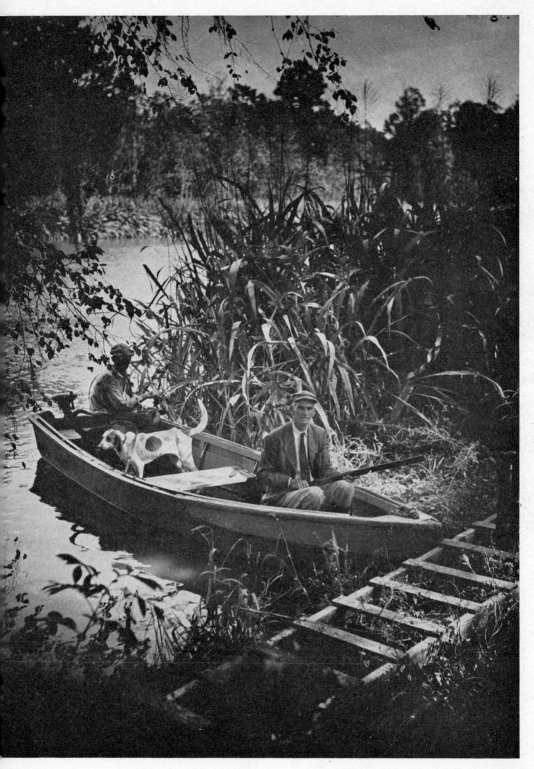

Starting after deer in the river swamp.

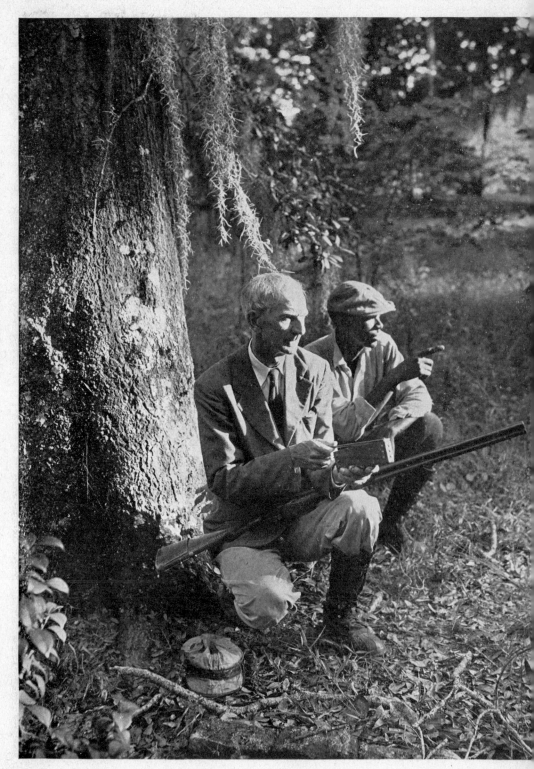

Calling up a wild turkey gobbler.

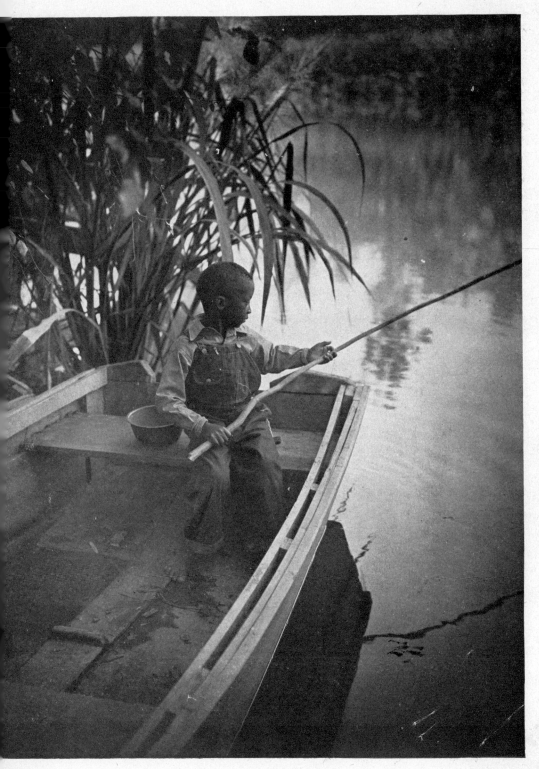

Blue waiting for a bite.

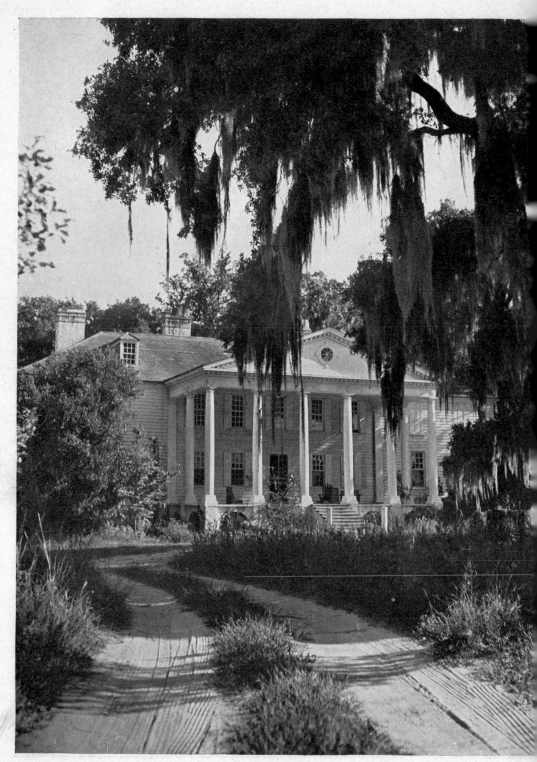

God's Children love the Great House. It is not mine, but ours.